IMAGES
of America

PORTLAND

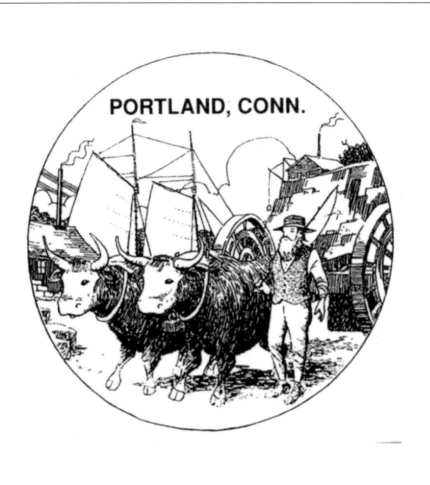

The Portland town seal depicts a typical brownstone quarry scene. It features a quarryman driving a yoked pair of oxen that are pulling an arch with a sling of brownstone. A steam derrick, perched on the rim of the quarry cliff, and the rigging of the sailing ship in the Connecticut River are visible in the background. The seal was designed in 1966 for the town's 125th anniversary celebration by Phillip Gildersleeve, county editor for the *Middletown Press* and a noted Portland illustrator. The seal was adopted by the board of selectmen on October 31, 1969. (Town meeting records, volume 4, page 305.)

IMAGES of America

PORTLAND

Robert W. McDougall

ARCADIA
PUBLISHING

Published by Arcadia Publishing
Charleston SC, Chicago IL, Portsmouth NH, San Francisco CA

Printed in the United States of America

Library of Congress Catalog Card Number:

For all general information contact Arcadia Publishing at:
Telephone 843-853-2070
Fax 843-853-0044
E-mail sales@arcadiapublishing.com
For customer service and orders:
Toll-Free 1-888-313-2665

Visit us on the Internet at www.arcadiapublishing.com

On the cover: This photograph was taken on Saturday, August 8, 1938, at the Middletown-Portland Bridge opening celebration on the front steps of the Strong and Hale Lumber Company. Pictured are company president John C. Barry, J. Alfred Dodd, Josie Bowman, and Esther Puglisi.

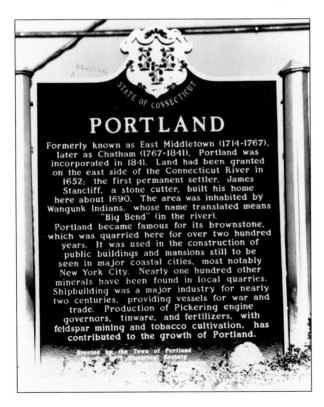

This local history marker was placed next to the town hall on Main Street during the nation's bicentennial celebration.

CONTENTS

ACKNOWLEDGMENTS

I wish to thank the members of the Portland Historical Society for the use of their collection in compiling this book, and I would especially like to thank the countless individuals who took these photographs, cared for them over the years, and donated them to the society.

The Portland Historical Society Calendar Committee members from 1983 to 2004 worked to research the captions for the annual calendars, which were a valuable reference for this book. Those members are Marion J. Anderson, Raymond W. Anderson, Ruth Callander, Daniel Crowther, Eleanor Crowther, Patricia E. Csere, William F. Csere, Francis B. Ellsworth, Herbert M. Ellsworth, Lib Ellsworth, John H. Dillon, John M. Dillon, Mary H. Flood, Phyllis Frisbie, William Frisbie, James B. Gildersleeve, Richard Gildersleeve, Helen Hanson, Robert S. Hinze, George V. Johnson, Martha Johnson, Harold Kreiger, Mandy Kreiger, Robert W. McDougall, Walter Olsen, Robert J. Pozzi, Hazel Robinson, Doris Sherrow-Heidenis, Christine Sullivan, Francis Sullivan, George F. Thiffault, Charles Woltmann, and Regina Woltmann.

Thanks to Pat and Eleanor Crowther, Walter and Vivian Dower, Myron and Jane Foster, and Arthur and Sonia Johnson for the use of images from their personal collections.

Special thanks to Doris Sherrow-Heidenis for her assistance with research and fact review, and to Luiza A. Penachio for understanding and encouragement.

Thanks, too, to Shannan Goff, my editor from Arcadia Publishing, for her patience with the many last-minute changes and refinements.

The Portland Historical Society can be contacted at Portland Historical Society Inc., Ruth Callander House Museum of Portland History, P. O. Box 98, Portland, CT 06480-0098. The society's Web site can be viewed at www.PortlandHistSoc.Org.

To the founders, members, and supporters of the
Portland Historical Society, without whose foresight,
generosity, and dedication this material would not
have been collected, preserved, and shared.

To my parents, Donald and Constance McDougall,
who encouraged my interest in history and allowed me to join the
Portland Historical Society as a charter member in 1973 at the age of 12.

INTRODUCTION

In 1974, the Portland Historical Society was established by a group of individuals interested in collecting and preserving material related to the town's history. The area known as Portland today has a rich history. One of the first lessons every schoolchild in Portland learns about the town is how to locate it on the map in the big bend of the Connecticut River near the center of the state. Strategically located on the navigable portion of the lower Connecticut River, the area contains natural resources that provided a prosperous livelihood for generations of residents. Portland is home to the world-famous brownstone quarries that provided building stone to major cities, from the townhouses in New York and the Back Bay of Boston to the Flood Mansion in San Francisco.

First settled as part of Middletown, the area has been known as the East Parish, then as Chatham, and was briefly called Conway. It was finally incorporated in 1841 as Portland, namesake of the famous quarry town in the United Kingdom. The abundance of lumber, the meadows gently sloping down to the river, and the demand for watercraft gave rise the great Gildersleeve shipyard that built and launched commercial and military vessels from this area for over 100 years. Blessed with the fertile river valley soil, this area was also famous for its shade-grown tobacco. From nearby hills, the acres of tobacco netting resembled a massive patchwork quilt covering the landscape, rolling like ocean waves in the warm winds of summer.

But Portland was more than a river valley town; its borders extended east from the plains along the river to the hills of Meshomasic, the first state forest in New England. The highlands were also home to "Bucktown," where the classic horse-drawn wagon, the buckboard, was invented. Strickland Quarry on Collins Hill is world famous among rock hounds, as more than 90 varieties of minerals have been found there.

On July 27, 1998, the Connecticut River was designated one of 14 American Heritage Rivers. That heritage has deep roots in Portland. Ever since the town's original affiliation with Middletown, crossing the river has always been a significant challenge for residents and visitors alike. Several ferry operations provided passage across the river for over a century. In 1876, the first bridge across the river in this area was built by the railroad and became part of the line from New York to Boston. It was called the "Air Line" because it was the most direct route between the cities. In 1895, the first highway bridge was built and featured the longest draw in the world at that time. Mother Nature humbled these structures, despite their grand designs, with the great flood of 1936, which led to the construction of the Middletown-Portland Bridge, later renamed the Charles J. Arrigoni Bridge. It has the longest span length of any bridge in the state. When the bridge opened in 1938, it received the American Institute of Steel Construction (AISC) Annual Award of Merit for Most Beautiful Steel Bridge, Class A. This bridge is still in service today and is the largest bridge on the Connecticut River. It is the only highway crossing between Wethersfield to the north and East Haddam to the south.

While Portland hosted a wealth of enterprises, it was also home to many industrious and successful individuals who built homes to reflect their success. Portland is home to the only twin pair of octagon houses in the world. The 1852 brownstone home of Jonathan Fuller, a quarry owner, was acquired by the town in 1894 and converted into the town hall. The building was recently renovated and now houses the Portland police department, youth services department, parks and recreation department, and the Buck-Foreman Community Center.

In 2001, the town offices moved into the completely renovated *c.* 1888 Central School building, which had served many generations of Portland students.

Visitors to Portland today will be pleased to learn that the brownstone quarries were designated a National Historical Landmark by the National Park Service in 2000. In 1998, Mike Meehan, a local geologist, reopened a small brownstone quarry operation on the north rim of the historic quarry to provide stone for the restoration of numerous brownstone buildings around the country.

Through the photographs in this book, you will be able to take an illustrated journey through some of the rich history of this quiet little town, known today for its golf courses and marinas.

Robert W. McDougall
Portland, Connecticut
July 2004

One

PARADES AND CELEBRATIONS

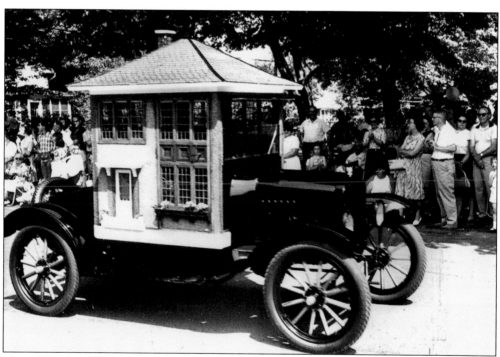

This 1922 Model T Ford was built for the Strong and Hale Lumber Company in Portland. This unique advertising vehicle was used in many parades and was employed by Strong and Hale Lumber Company to keep the lumberyard in the public eye. This car has been in the town of Portland all its life, and it was also under water in the 1936 and 1938 floods.

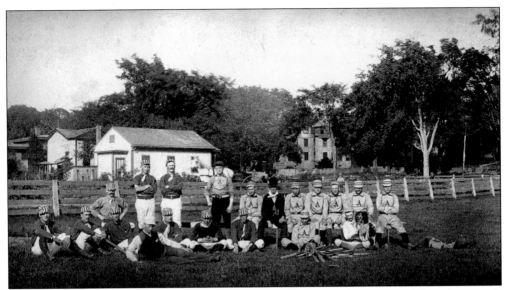

Baseball, the great American pastime, has been long been popular in town. This photograph shows the Portland club in dark shirts and the New Britain club in light shirts.

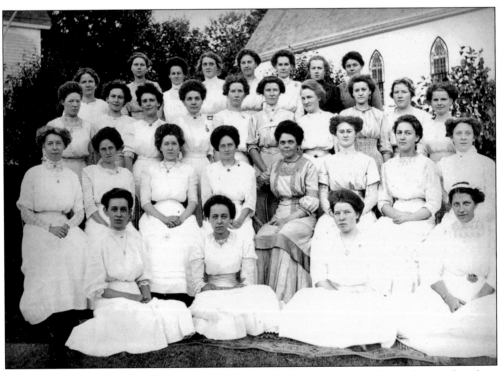

The Lutheran Ladies group is shown here on Waverly Avenue next to the Lutheran church.

This 1913 poster advertises movies at Waverly Theatre, also known as Waverly Hall, located on the north corner of Waverly Avenue and Main Street. This flier was printed by the Middlesex County Printery in Portland.

TO-NIGHT!

Waverly Theatre

THURSDAY EVENING, NOV. 20, 1913

Motion Pictures!
5 New Reels!

THE PROGRAM IS AS FOLLOWS:

" THE STRUGGLE "
A 2 Reel 101 "Bison" Western Drama.
" THE FOLLY OF IT ALL "
A Splendid Dramatic Subject.
" HER LITTLE DARLING "
"WHAT PAPA GOT"
Two Splendid Comedies.
"THE RETRIBUTION OF YSOBEL"
A Thrilling Mexican War Story.

ADMISSION:
Adults, 10c. Children, 5c.
Pictures Changed Daily

Middlesex County Printery, Portland, Conn.

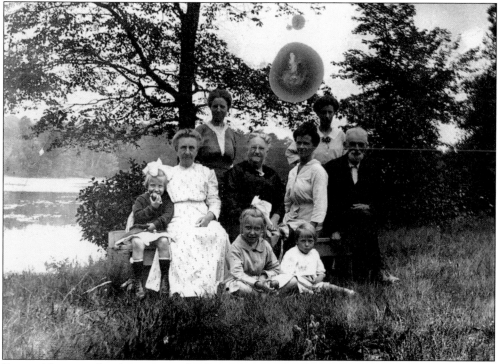

Pictured here is a family picnic in the Pecausett section of town c. 1915.

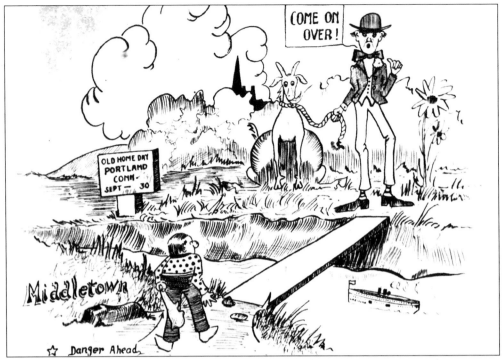

This 1916 cartoon was given to Judge Thomas C. Flood by John C. Barry, a prominent businessman in Portland. Both men served on the town's 75th Anniversary Committee in 1916.

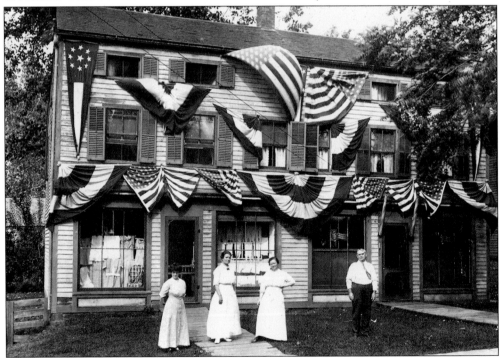

Pictured here on lower Main Street in 1916 are William Callahan in front of his barbershop, neighbor Katherine Sullivan in front of her dress shop, Annie Carroll, and an unidentified woman.

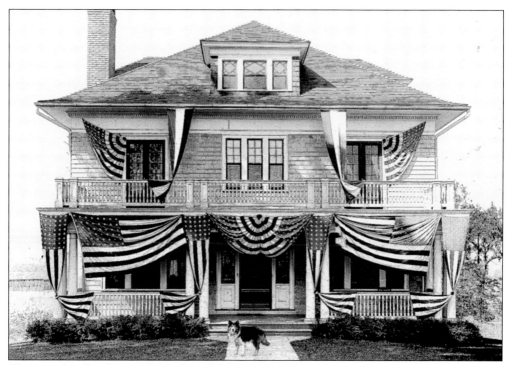

This proud collie shows off Alvah and Addie Payne's home at 516 Main Street. The house is decorated for the town's 75th anniversary in 1916.

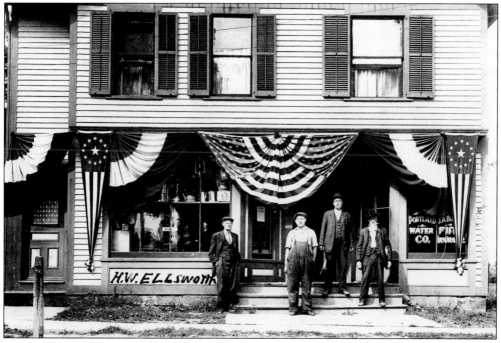

H. W. Ellsworth's Store at 264 Main Street is decorated for Old Home Day, September 30, 1916. Seen here, from left to right, are Daniel Hall, H. W. Ellsworth Jr., H. W. Ellsworth, and Thomas Stewart.

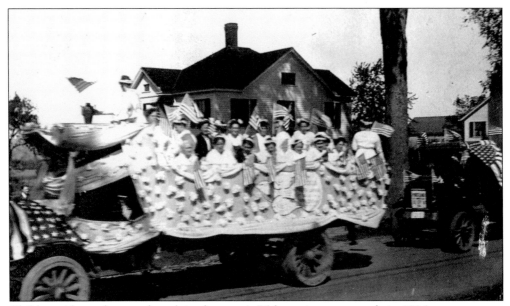

Children ride on decorated truck in the town's 75th anniversary parade in 1916.

The town's 75th anniversary parade passes in front of 518 Main Street.

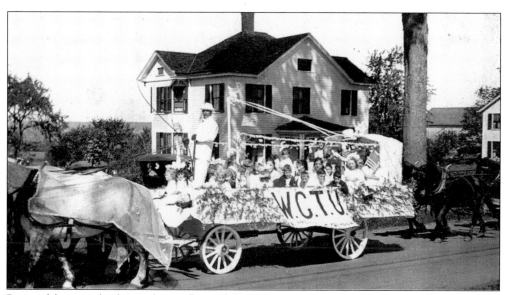

Pictured here is the horse-drawn float of the Women's Christian Temperance Union in the town's 75th anniversary parade.

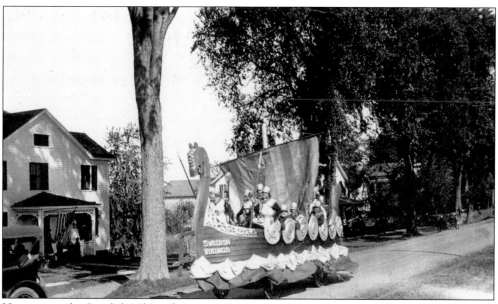

Here we see the Swedish Viking float participating in the anniversary parade. Note the elm trees that lined Main Street at the time. Most of these trees have been lost to blight and storms.

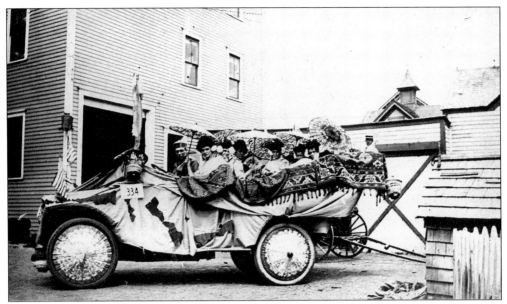

Pictured here is Fred Haines with his car, which is decorated for the 75th anniversary parade.

In May of 1841, the portion of the town of Chatham known as the First Society of Chatham was set off as a separate town and named Portland. Its territory was nine miles long and three miles wide. At the time this photograph was taken in September 1916, the town was celebrating its 75th birthday under the name of Portland. Seen here, from left to right, are Thomas C. Flood, judge of probate; Herbert E. Ellsworth, first selectman; and Harry Howard, town clerk.

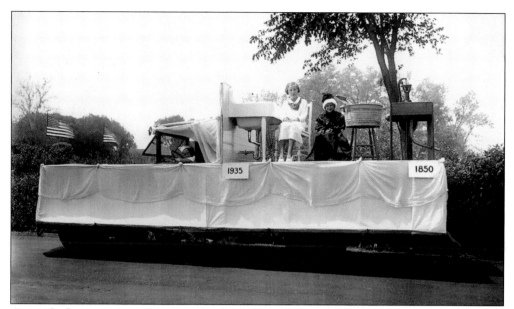

A parade float compares domestic plumbing from 1850 with "modern" 1935 plumbing. Seen from left to right are Walter Dower Jr., Beverly Ellsworth, and June Dower.

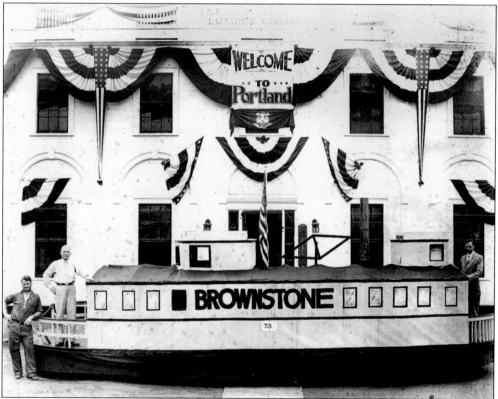

John C. Barry and Alfred C. Dodd, owners of the Strong and Hale Lumber Company, are shown here on their float, the ferry boat *Brownstone*, in the 1938 parade held to mark the opening of the Middletown-Portland Bridge.

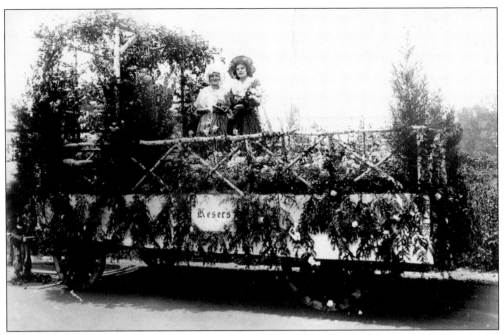

Pictured here is a parade float presented by Keser's Florist. Kay Keser, who managed a greenhouse operation in town for many years, is shown on the left in this 1941 photograph from the town's 100th anniversary parade.

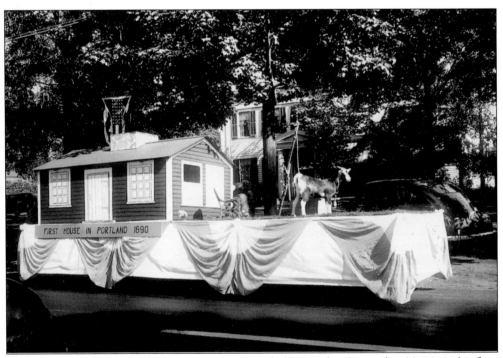

Participating in Portland's 100th anniversary parade held Saturday, September 20, 1941, this float represents the *c.* 1690 James Stancliff house, believed to be the first house built in the town.

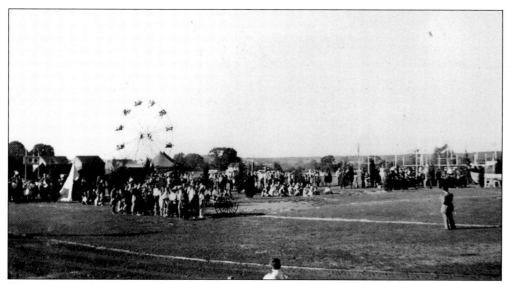

This photograph shows festivities on Middlesex Avenue during the 1941 centennial parade and celebration. The Prout property in the foreground also served as a fairground until it was subdivided for a housing development.

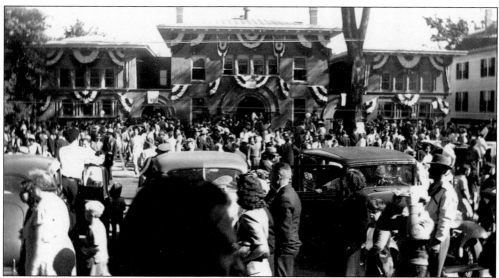

Governor Hurley was present to do the honors in 1941 for the grand opening of the new north wing of the town hall. This building was renovated and reopened in 2003 to house the Portland police department, the Buck-Foreman Community Center, the parks and recreation department, and the youth services department.

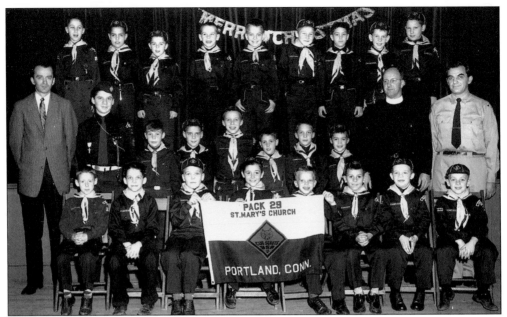

Cub Scout Pack 29 is shown here in 1959 with leaders Bill Nolan, Fr. Tom Ahern, and Ted Sims.

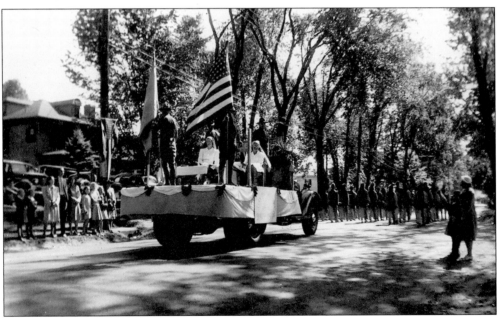

Stately elms once lined Main Street. This scene shows a parade passing 383 Main Street near Church Street. The distinctive capes of the Portland High School Band can been seen beyond the float.

20

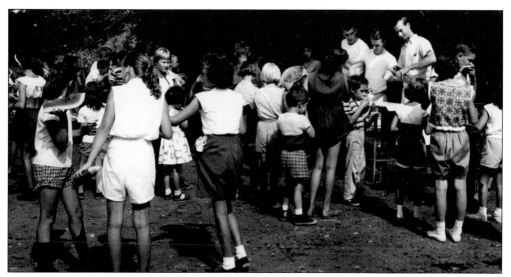

Portland Super Market hosted a watermelon-eating party on August 23, 1960.

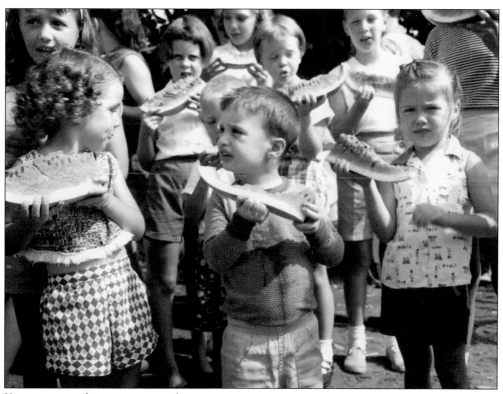

Young watermelon eaters enjoy the party.

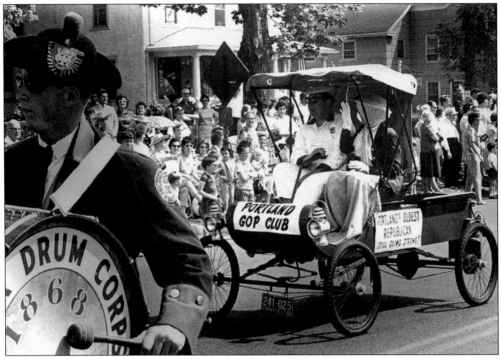

Mabel Steele, Portland's oldest Republican, is shown here riding in a car in front of 255 Main Street during the town's 125th anniversary parade in 1966.

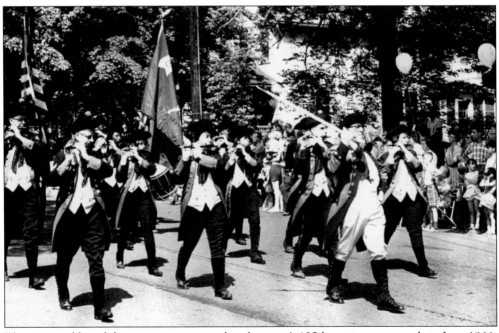

This visiting fife and drum corps participated in the town's 125th anniversary parade in June 1966.

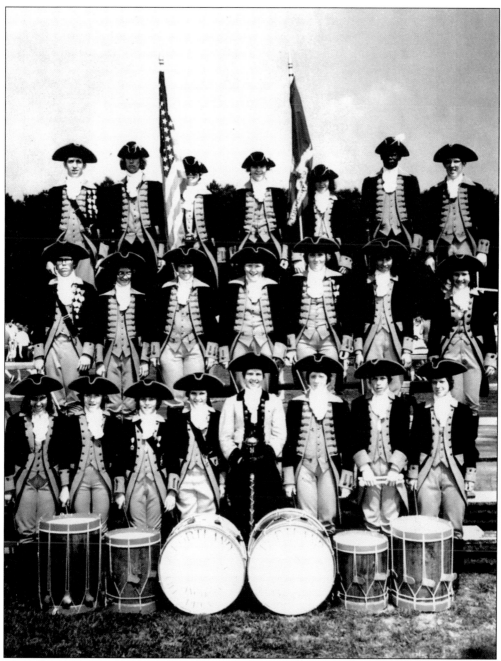

The Portland Ancient Fife and Drum Corps (organized in 1972) is shown here in July 1976 at the Yalesville competition of the Connecticut Fifer's and Drummer's Association, where its color guard placed first for the von Steubon manual of arms. Pictured, from left to right, are the following: (First row) Lynn Benashski, Michelle Stevens, Kim Stevens, Craig Murphy, Drum Major Ginny Stephanchick, Janine Sterry, John Paul Bisson, and Michelle D'Orio; (second row) John Stephanchick, Gina D'Orio, Robyn Willmore, Alice Vannoy, Kathy Murhpy, Karen Benashski, and Maria Masselli; (third row) Peter McDougall, Michael Woynar, Jeanne Marie Simpson, Regina Bisson, Valerie Walker, Kenneth Fletcher, and Robert McDougall.

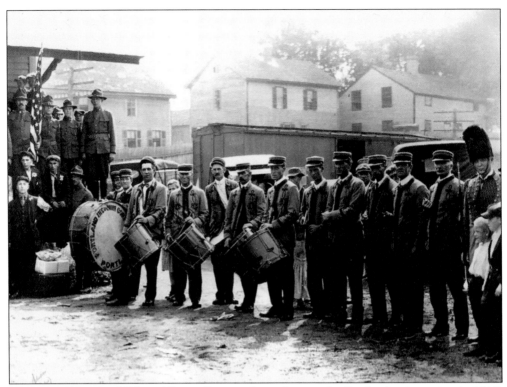

The original Portland Fife and Drum Corps is shown here at the Portland train station in 1917. The corps members pictured, from left to right, are the following: bass drummers George Ames and Alfred Bengston; snare drummers George Stocking, Joseph Synnott, Frederick Cornwall, Percy Hurlburt, and George Wilcox; fifers John Cavanaugh, Will Stocking, Leo Gotta, Daniel Kelsey, and Will Synnott; and drum major Luther Wilcox.

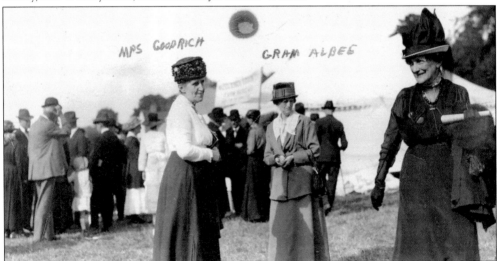

Here we see the old Portland Fairgrounds on Main Street at the foot of Fairview Street, where the high school was built in 1931. The ladies in front, from left to right, are Mrs. Goodrich, Gram Albee (Harold Cramer's grandmother), and Mrs. Butler. Chautauquas were also held on these grounds in the form of lectures, concerts, and summer schools.

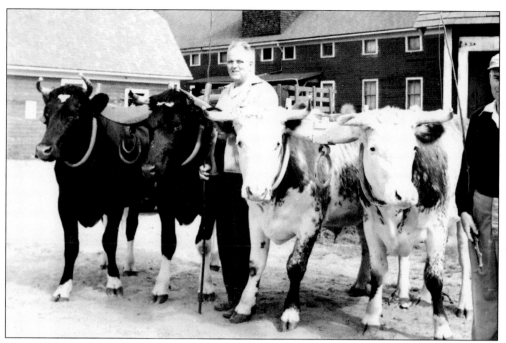

Harry Hale gets his oxen ready for the 1953 Portland Fair.

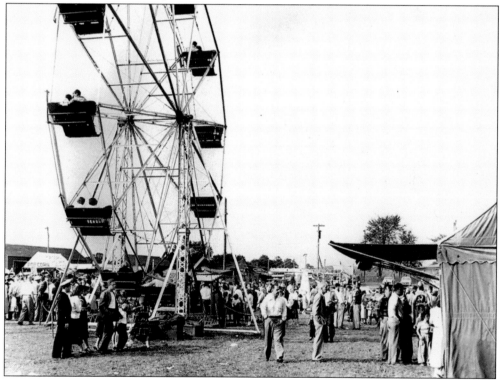

The Ferris wheel is shown at the 1954 Portland Agricultural Fair, which was an annual tradition in town for many years. Although inactive during the 1990s, it has been enjoying a revival since the Portland Fair Association restarted it in 2000.

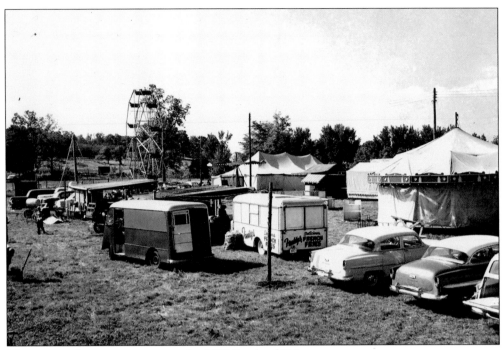

This is an early morning scene at the 1954 Portland Fair.

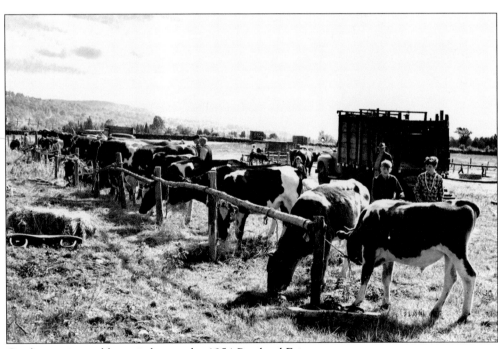

Cattle are pictured here tied up at the 1954 Portland Fair.

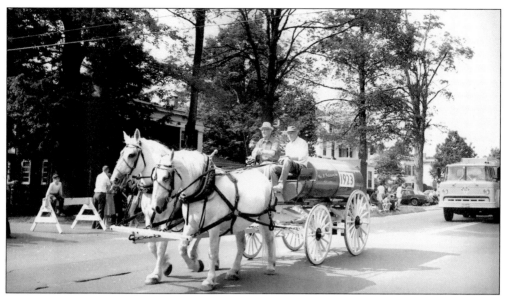

William R. Peterson, who founded Portland's Wm. R. Peterson Oil Company in 1923, is shown here riding a restored horse-drawn tank wagon identical to those used in Portland in the 1920s before the advent of motorized vehicles. Note the modern tank truck following the wagon. This type of tank wagon delivered kerosene to Portland homes more than 100 years ago. Currently the Portland Historical Society museum's largest artifact, the tank wagon is on display behind the museum during the summer season.

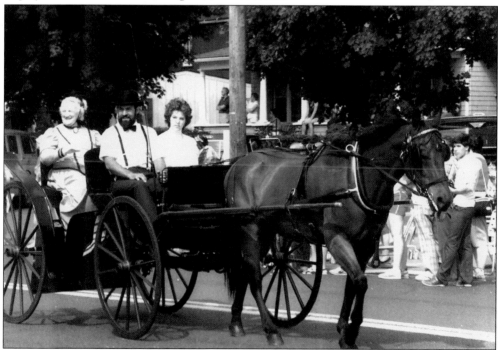

The Portland Fire Department's 100th anniversary parade was held on June 23, 1984. Dorothy Robinson, president of the Portland Historical Society, is shown here riding in a horse-drawn carriage. She is in the back seat on the left.

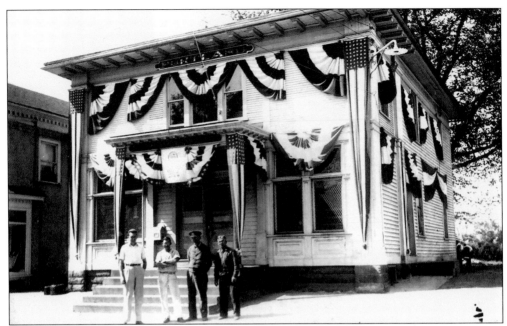

Andy Hetzel, Stan Basiel, George Bodistrin, and Al Mays are shown here in front of the Portland post office, which is decorated for the town's 100th anniversary in 1941. These men carried mail to Portland, Gildersleeve, Middletown, and Cromwell.

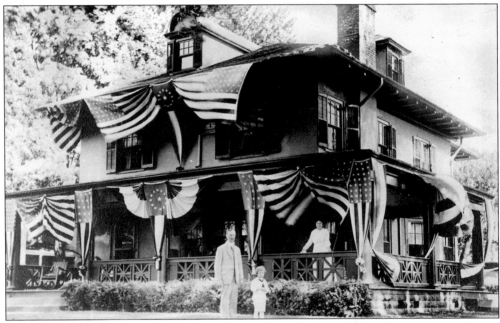

This home was built at 377 Main Street in 1911 for prominent Portland businessman George C. Pascall, his wife Helen, and their son Richard. This family photograph was taken in 1916 when the house was decorated for Old Home Day. The house was designed by the architectural firm of W. H. Cadwell of New Britain and is of the Arts and Crafts or Mission styles popular in the early part of the 20th century. The Pascalls owned the home for 53 years until it was sold to Norma and Tom DeGraff in 1964. They in turn sold it to Jan and Dan Davis in 1986.

Two

FLOODS AND HURRICANES

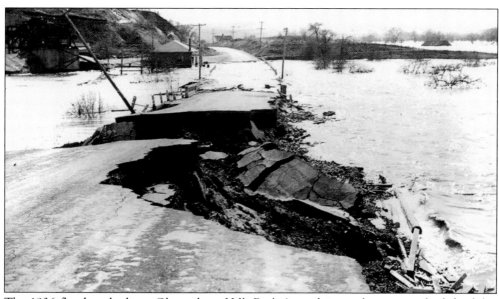

The 1936 flood washed out Glastonbury Hill. Butler's sandpit can be seen to the left of this view, which looks south down Route 17.

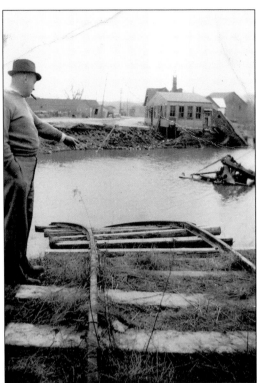

The 1936 flood washed out a portion of the rail bed near the quarry.

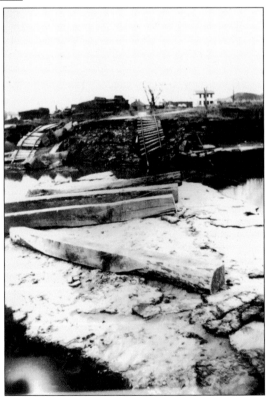

This is a view of the washed-out rail tracks near the quarry after the 1936 flood waters had subsided.

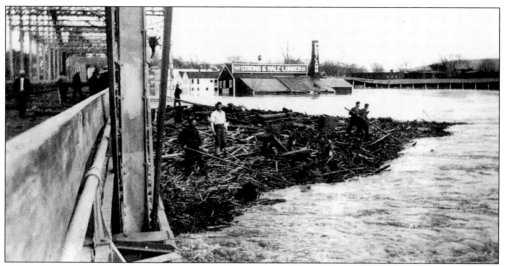

Debris from the 1936 flood collected against the highway bridge.

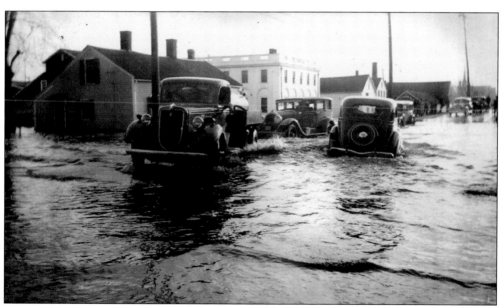

Lower Main Street was under water during the 1936 flood. The white building in the center is the Strong and Hale Lumber Company office, which appears on the cover of this book.

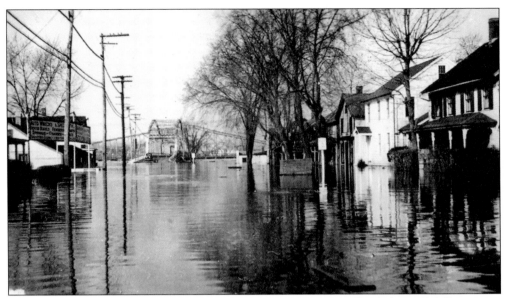

The approach to the highway bridge from lower Main Street was flooded in 1936. Every year, Portland experiences some flooding along the Connecticut River. On March 21, 1936, the river crested at 30.21 feet above normal, a record that still stands today.

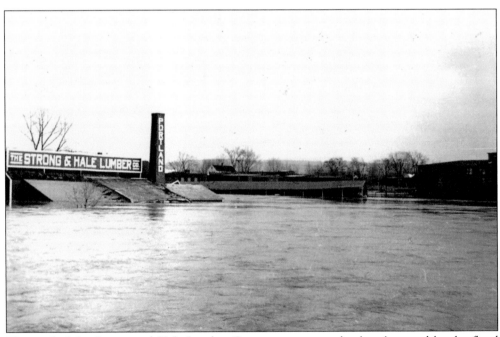

The yard of the Strong and Hale Lumber Company was completely submerged by the flood waters in 1936.

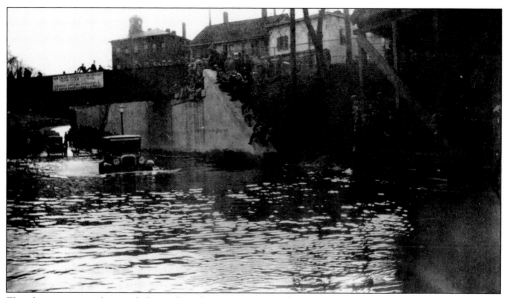

Flood waters rose beyond the railroad overpass toward Main Street in Middletown.

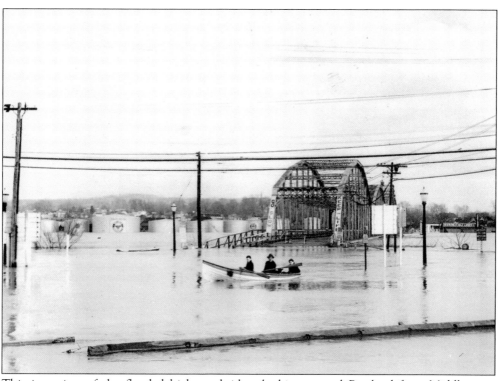

This is a view of the flooded highway bridge, looking toward Portland from Middletown. The oil tanks in Portland can be seen clearly on the other side of the flooded river.

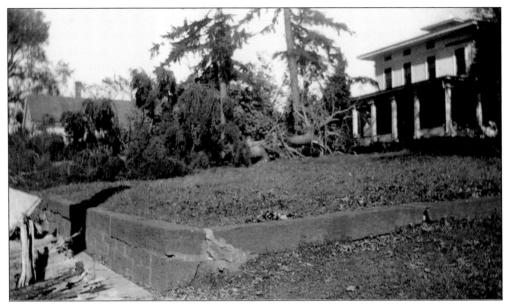

The 1938 hurricane uprooted trees at 319 Main Street, Henry and Lucy Ibbotson's home. As a result of the heavy rains from Hurricanes Connie and Diane, the Connecticut River crested 27.35 feet above normal on September 4, 1938.

The trees uprooted by the 1938 hurricane lifted sidewalks in front of E. Irving Bell's home at the northeast corner of Main and Fairview Streets.

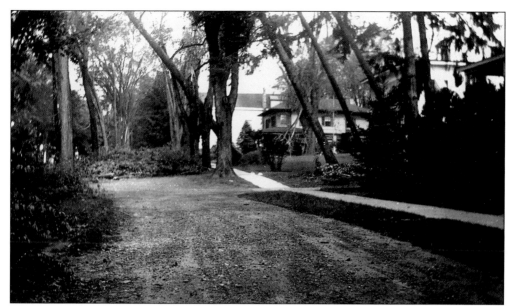

Here we can see more damage on Main Street from the 1938 hurricane. This view looks north toward Church Street.

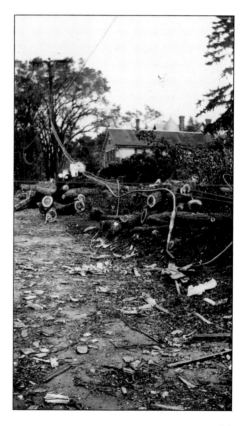

The Betsy Kelsey home at 321 Main Street, built c. 1825, can be seen here behind the extensive tree damage from the 1938 hurricane.

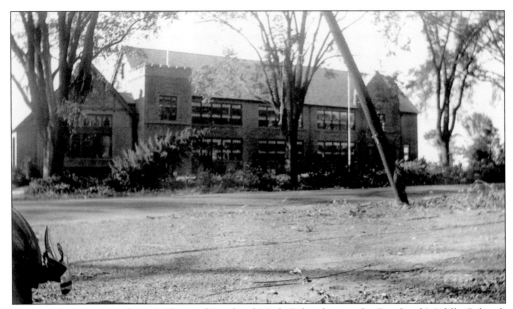

Trees and wires came down in front of Portland High School, now the Portland Middle School, on Main Street in 1938.

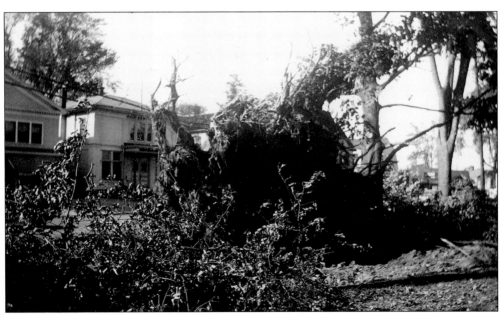

The 1938 hurricane uprooted a tree in front of the Charles Bell house, 259 Main Street, next door to the town hall and opposite the post office at 258 Main Street.

Looking north at the corner of Main and Marlborough Streets in 1938, a large uprooted tree can be seen in front of the Mary Sellew house, which was torn down in the 1940s to make way for a car dealership. This is currently the site of Brooks Pharmacy.

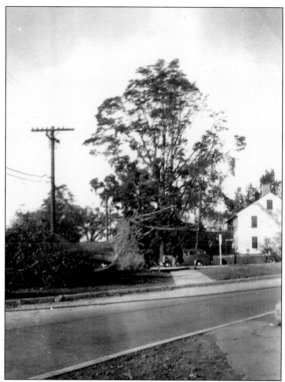

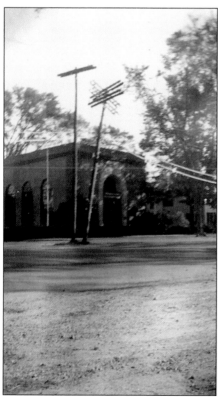

The Portland Trust Company, located on the corner of Main Street and Waverly Avenue, survived the 1938 hurricane.

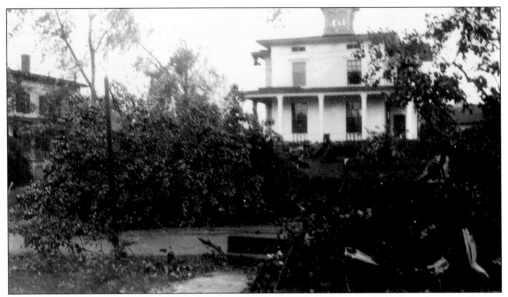

Gildersleeve was also ravaged by the hurricane. The Randall home at 625 Main Street is shown here on September 23, 1938.

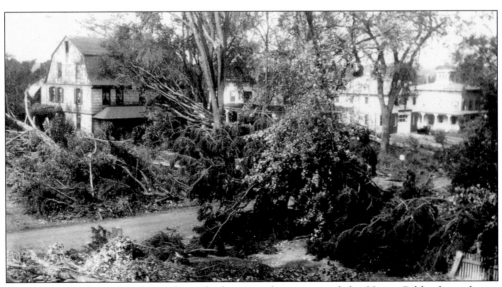

Extensive tree damage is shown here, looking northwest toward the Harry Gildersleeve home at 628 Main Street. Also visible are 632, 634 (Engine Company No. 2), and 638 Main Street, which still had its cupola.

Trees and power lines came down in front of 624 Main Street, shown here on September 22, 1938.

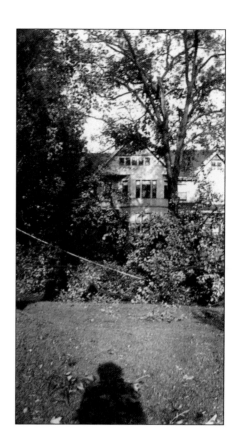

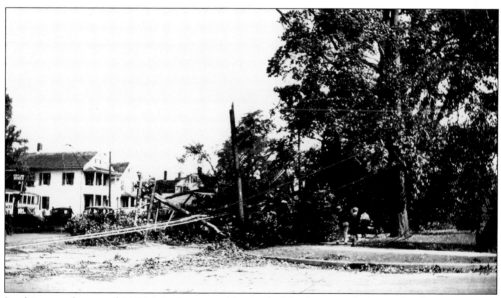

Looking north toward 216 Main Street and beyond, this photograph shows the damage to trees and power lines from the 1938 hurricane and offers a rare glimpse of Dusty's Diner on the left at 210 Main Street.

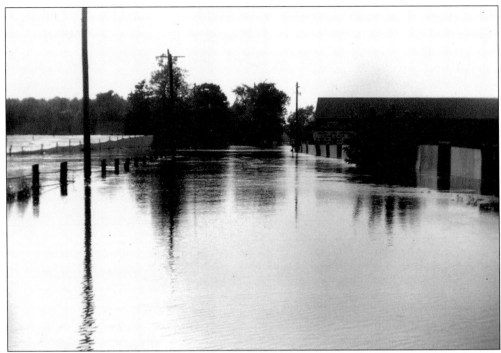

In August 1955, there was another significant flood, though it was not as severe as the flood in 1936. This westward view of the flooded Route 17A shows the netted tobacco fields on the left and the entrance to the Portland Drive-In Theatre in front of the tobacco barn on the right.

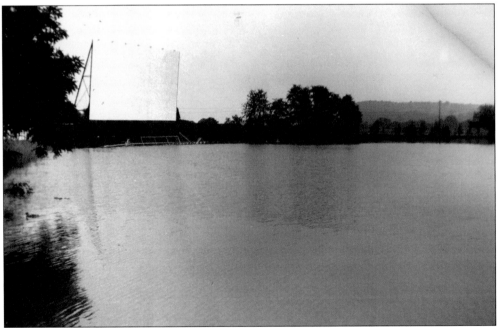

Only the movie screen can be seen in this southeast view of the drive-in; flood waters covered the parking area during the 1955 flood. The Connecticut River crested at 22 feet above normal on August 20, 1955.

40

Three

LANDMARKS
PAST AND PRESENT

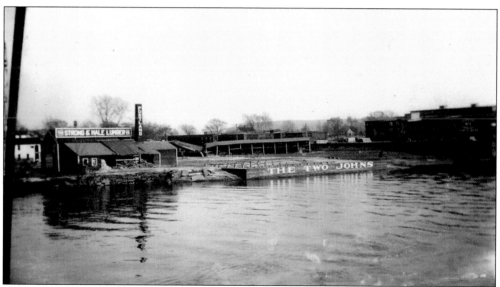

Before the famous "Come On Over" appeared on the retaining wall next to the Strong and Hale Lumber Company, the sign displayed a tribute to the new owners of the business: it read "The Two Johns," referring to John C. Barry and John A. Dodd. They purchased the business in 1912. The "Come On Over" sign was probably first painted in 1925.

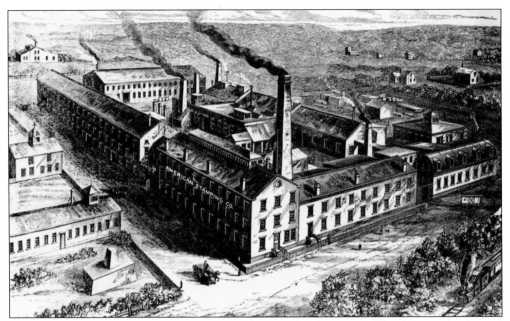

The Eastern Tinware Company was organized in Portland in 1888. The factory also housed the American Stamping Company and the Pickering Governor Company. It was located on Freestone Avenue.

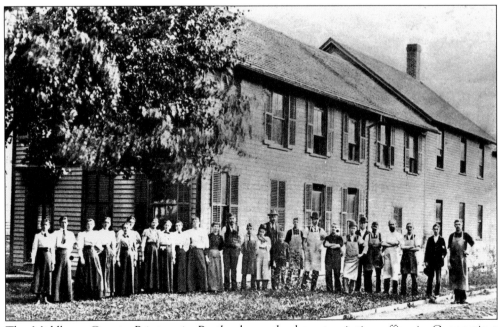

The Middlesex County Printery in Portland was the largest printing office in Connecticut south of Hartford and east of New York.

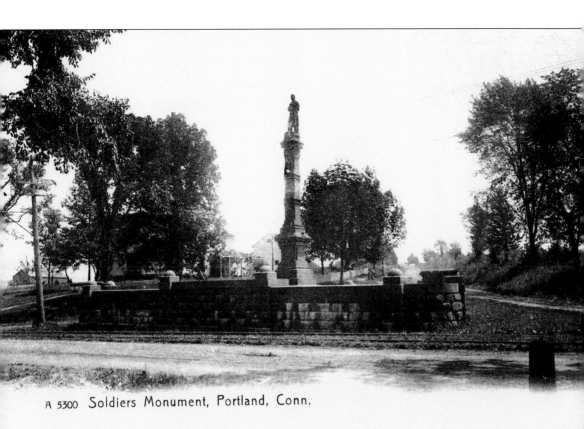

A 5300 Soldiers Monument, Portland, Conn.

At a special town meeting on September 9, 1871, the town voted to "erect a brownstone monument to the memory of our dead soldiers." The monument would cost $4,000 and was to be enclosed with a suitable fence. The members of the committee chosen to select a site and supervise the erection of the monument were Frederick A. Parker, Asaph Strong, John I. Worthington, Seth I. Davis, and Ferdinand Gildersleeve. The monument, a graceful shaft of native stone, is 33 feet high and surmounted by a lifelike statue of a soldier standing at rest. The monument was placed across from the First Congregational Church at the intersection of Main Street and Bartlett Street. The cutting of the stone was done at Batterson's in Hartford. The front of the monument is ornamented with an eagle and shield and inscribed as follows: "Erected May 30th 1872, by the town of Portland to the memory of her brave sons, who gave their lives in defense of the Union during the War of the Rebellion 1861–1865." The retaining wall around the monument was later lowered to improve visibility for motorists.

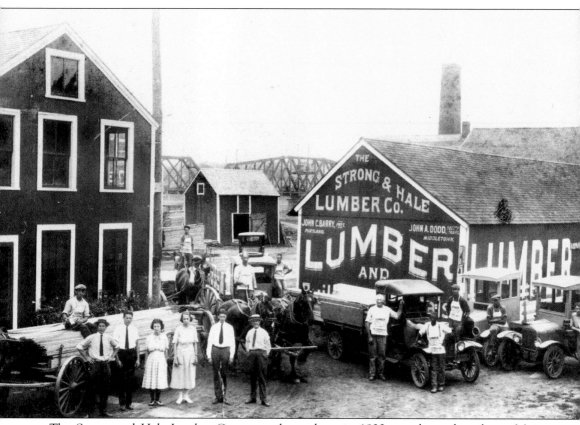

The Strong and Hale Lumber Company, shown here in 1922, was located on lower Main Street. Pictured, from left to right, are the following: (at front left) Fredolf Walstedt (on wagon), worker John C. Barry, unidentified, Genevieve Barry, Ruth Bostrom-Bergeson, J. Alfred C. Dodd, and John A. Dodd; (at right) unidentified, worker Lemon Smith, and three unidentified men; (at rear) Algot T. Walsted (at the front of the wagon) and Carl A. Bengston (at the right of the wagon). The other man at the rear is unidentified.

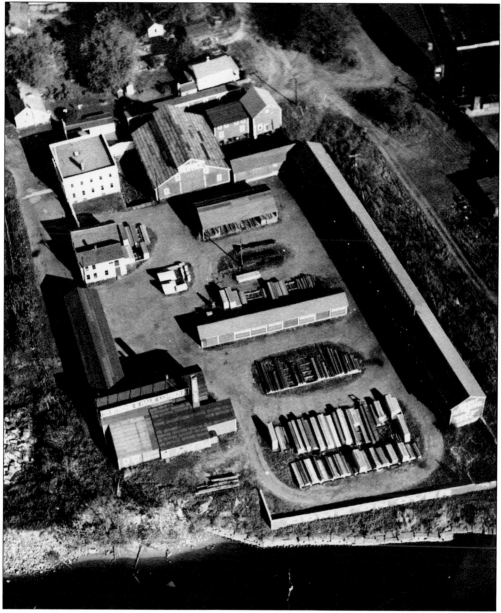

This aerial photograph shows the Strong and Hale Lumber Company in its heyday. The larger of the two square buildings on the left still stands; it served as the Portland Senior Center in the 1970s and 1980s. In the 1990s it served as the Youth Services Center. On the lower left, between the river and the barrier at the end of Main Street, the remnants can be seen of the abutment for the first highway bridge between Portland and Middletown. The bridge was in use from 1896 until 1936, when it was replaced by the Arrigoni Bridge that is still in use today. This area was under the flood waters shown in the photograph for January. At the bottom right of the photograph, Portland's famous "Come On Over" cries out to the Middletownians. The sign shown here was painted on a brick wall that was replaced in 2000 with the new wall higher up the bank of the Connecticut River.

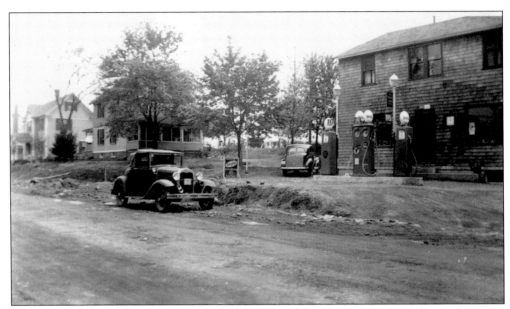

Seen c. 1927 is Louis Silver's gas station at the corner of Perry Avenue and Marlborough Street.

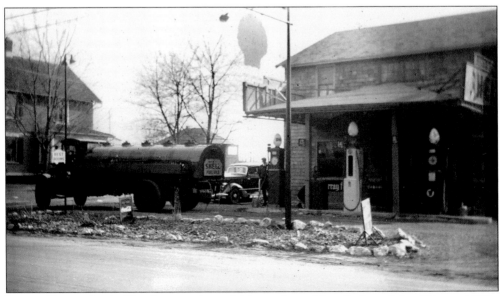

Pictured here is Louis Silver's gas station, which was last sold to Sadie and Art Klien c. 1930.

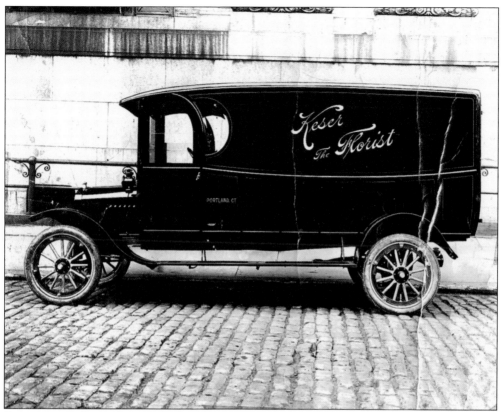

Delivery "panel" trucks such as this one used by Keser Florists in 1915 were not common at the time. Otto Keser purchased the chassis from Ford Motor Company, and Hays-Stevendorfer Company of New York produced the paneled body.

In 1903, Dr. Sellew sold the Riverside Greenhouses to Otto Keser, who incorporated with his sons Ben, Elliot, and Sid in 1920. Keser Florist ran a prosperous business at 517 Main Street until 1984.

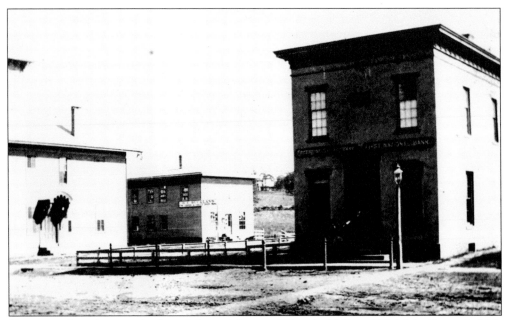

Shown in this photograph, from left to right, are Waverly Hall at 275 Main Street (which burned on January 22, 1918), Buckland's Tin Shop on Waverly Avenue, and the First National Bank and the Freestone Savings Bank at 269 Main Street. Waverly Hall was built in 1868 and had a seating capacity of 270 people.

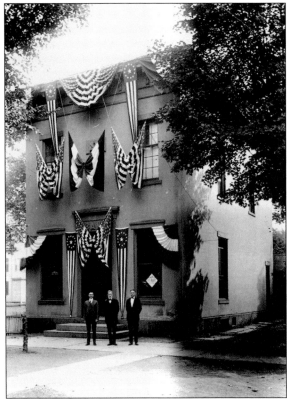

Bank officers George F. Cramer, John H. Sage, and Richard N. Gildersleeve are shown here in front of the First National Bank and Freestone Saving Bank, which were housed in this building in 1916.

On June 28, 1925, the local paper reported that "the merger of the First National Bank of Portland and the Freestone Savings Bank of Portland with the newly organized Portland Trust Company, [had] been consummated and both the First National Bank and the Freestone Savings Bank [were] liquidated, with the Portland Trust Company taking over all of the assets and liabilities." A handsome new banking home was constructed to house the needs of the Portland Trust Company. This building was constructed on the site of the old bank, which had been used by the First National Bank and the Freestone Saving Bank for over 60 years. The construction is of brownstone and tapestry brick with mahogany finish.

Looking out the front door of the bank reveals the First National grocery store across Main Street. In the 1980s, this building housed the United Bank and Trust Company. In 1995, it was acquired by Fleet Bank, and in 2004 the name changed again to the Bank of America.

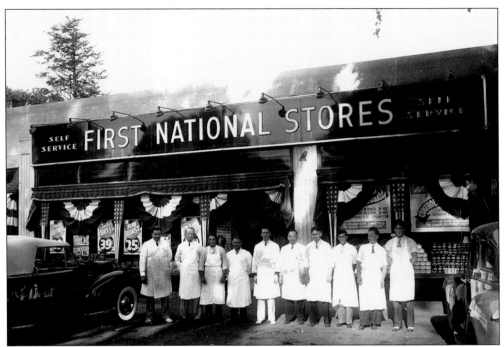

In 1941, the building now occupied by the Portland Country Market housed three stores: Wannerstrom's Electric, First National Stores, and R. H. Conklin Pharmacy. Included in this photograph of personnel from the First National Store are Paul Miano, Michael J. Curran, Morris Fabian, Herbert Williamson, Max Hejna, Karl Newsom, Carl Frenqueza, Emil Johnson, and William Csere. The car on the left was owned by Irving A. Chapman. Note the price of rib roast in the window, on sale for 25¢ per pound.

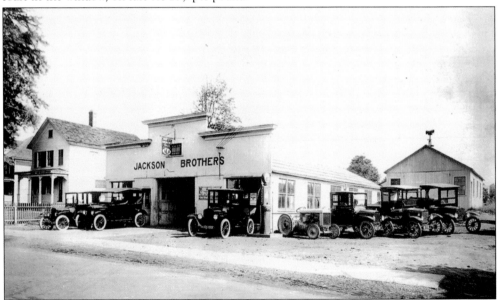

Jackson's, seen in this early photograph, was one of the early automobile dealers in town. It was based on Marlborough Street for many years. The latest model Ford vehicles, including a Fordson tractor, are on display in front of the business. The house to the left was demolished c. 1987.

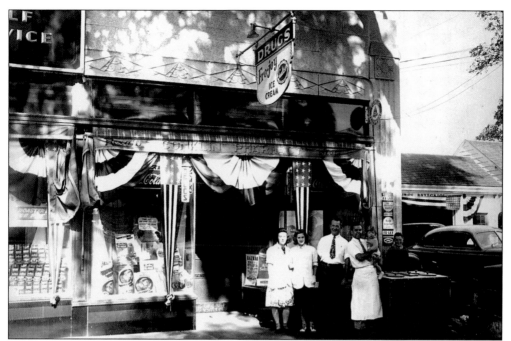

Shown in front of Conklin's Pharmacy at 274 Main Street are, from left to right, Ruth Campbell, Dorothy Larson, Mr. Conklin, James Natalie (holding Billy Conklin), and Roland Conklin Jr. This photograph shows the First National grocery store on the left and Peterson's gas station on the right. Roland H. Conklin bought Blodgett's Drug Store in 1922 from Charles Blodgett.

This photograph shows fire damage to Bransfield's grocery store at the corner of Airline Avenue and Main Street. The building was burned so badly that it had to be torn down. The town's first Catholic Mass was held in this building before the Catholic church was built.

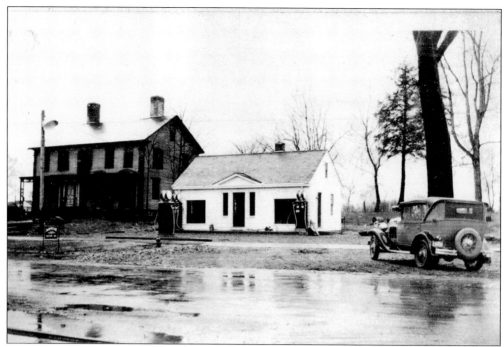

This photograph, taken in April 1929, shows the c. 1800 Daniel Russell house next to Wm. R. Peterson's gas station. Roy Barrow's DeSoto is nearby. Russell's Georgian-style home was then a boarding house called the Portland House. Portland Country Market, at 272 Main Street, now stands on the site, and Peterson's gas station has been replaced by Wm. R. Peterson Oil Company's two-story brick Federal-style building at 276 Main Street.

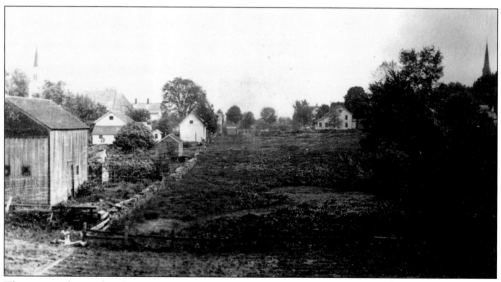

This scene shows the Coe Avenue farm where Tobe Hiller lived. Later, Sydney Edwards lived here. In the background is Main Street; the steeples of the Episcopal church on the left and the Methodist church on the right can be seen over the trees.

This postcard shows East Main Street in Portland when all the trees were small.

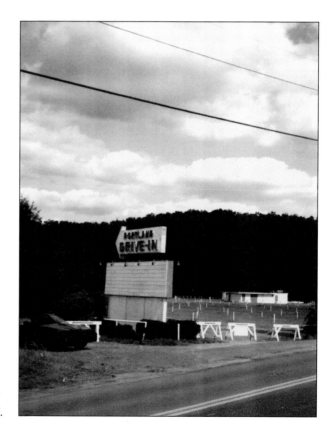

The Portland Drive-In Theatre operated at the corner of Route 17 and Route 17A from 1954 to 1986.

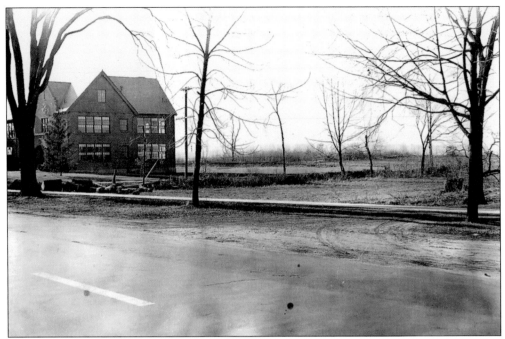

On January 31, 1941, contractor A. C. Accadi and Sons began construction of a new post office on the corner of Main Street and Middlesex Avenue. This southwest view from Main Street shows the vacant street corner and the high school across the street.

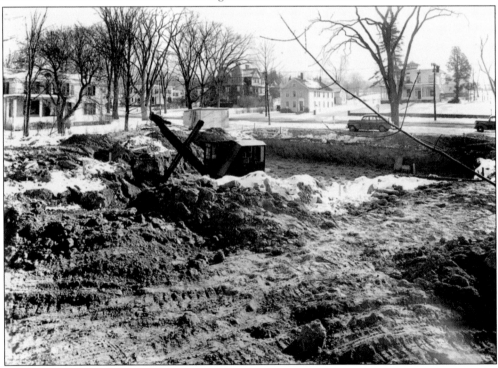

This view from the southwest corner of the lot shows a steam shovel digging the hole for the foundation. Notice the size of the trees along Main Street in 1941.

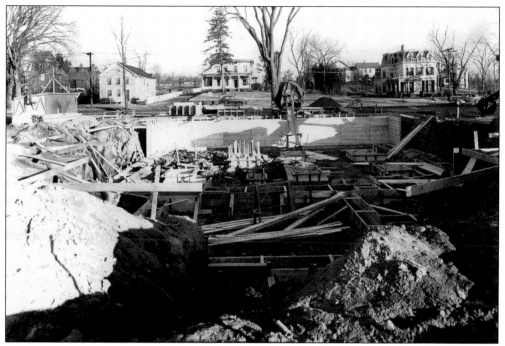

By February 24, foundation forms were being assembled. This view from the west provides a nice panorama of the houses along the east side of Main Street.

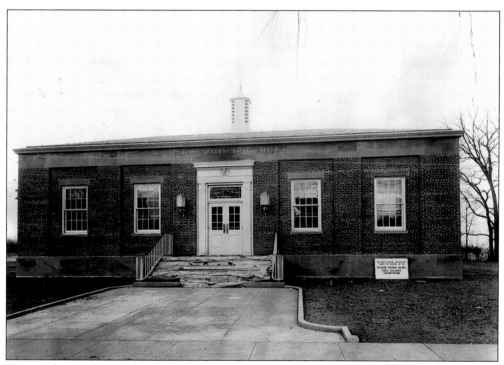

Here is the newly completed post office on January 15, 1942. This project was constructed under the control of the Federal Works Agency Public Buildings Administration.

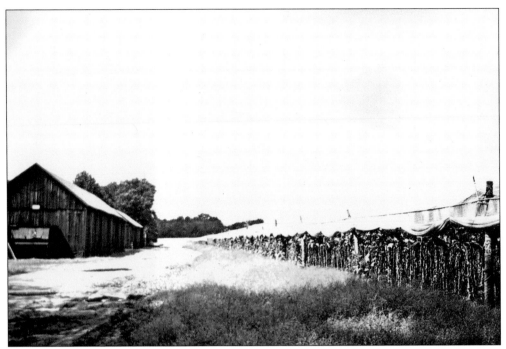

Shade-grown tobacco was an important crop to Portland's agricultural economy. Today, most tobacco fields have been converted to other uses, but the patchwork of Portland's landscape was once dominated by countless fields covered with tobacco netting that protected the leaves used for cigar wrappers.

This tobacco-drying shed is located on Route 17A. Only a few of these buildings remain. Tobacco farming provided a first employment opportunity for many of Portland's youth.

Mr. and Mrs. Thaddeus Sims are shown here in Galan Motors at the corner of Main and Marlborough Streets. John and Bob's service station, located next to Portland Restaurant, can been seen through the window.

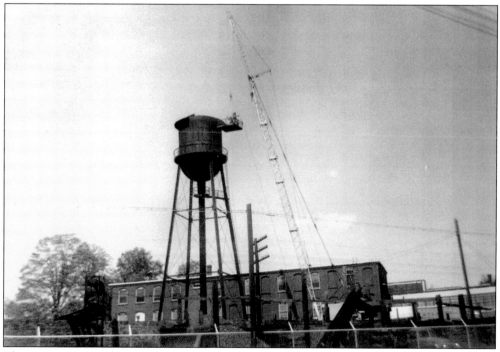

The water tower at the old Pickering Shop on Pickering Street was taken down in July 1962.

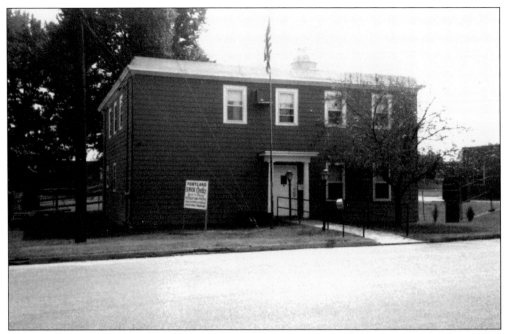

In 1986, the building at 5 Main Street, formerly the main office of the Strong and Hale Lumber Company, was serving as the Portland Senior Center. It is hard to believe this is the same building shown on the cover of this book.

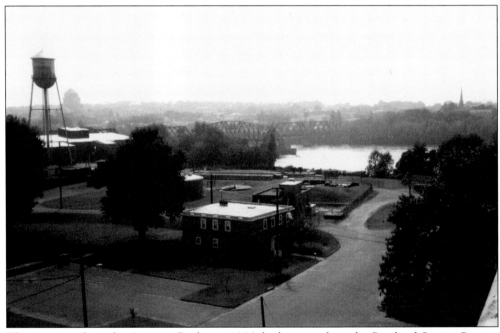

This is a view from the Arrigoni Bridge in 1986, looking south at the Portland Senior Center.

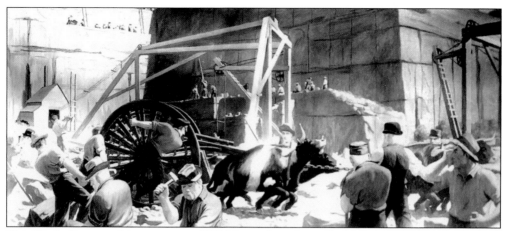

This Works Progress Administration (WPA) mural on the wall of the middle school auditorium illustrates the operations in the brownstone quarry.

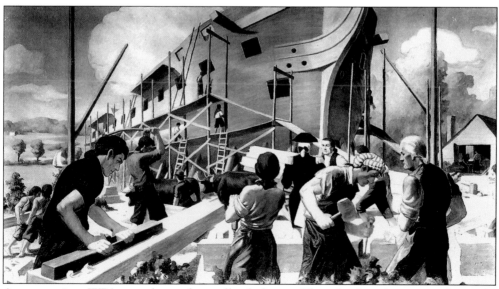

A companion WPA mural on the wall of the middle school auditorium reflects the once-prominent shipbuilding industry in the Gildersleeve section of Portland.

This is the c. 1855 George Cox house. Cox (1810–1880) was an English immigrant who purchased the three-acre site from Stephen Brainerd and Elijah Adams in May 1852. Brainerd and Adams also sold Cox the gristmill, sawmill, dam, and pond that had been operating on this site on Carr's Brook (now known as Cox's Brook) since the mid-18th century.

The house on the left, 434 Main Street, was known as the William H. Edwards house. It burned to the ground on February 19, 1947, at around 1 a.m. There is now a duplex home on this site. The house on the right is 440 Main Street

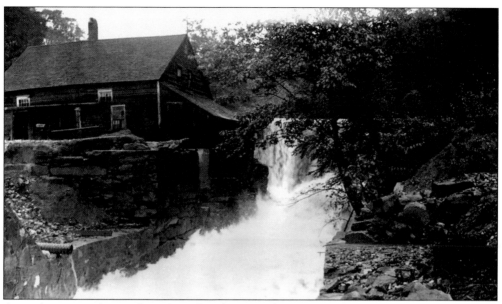

A steady stream of water from Cox's Brook was used to operate the gristmill built on Rose Hill Road in 1801 by Enoch Sage.

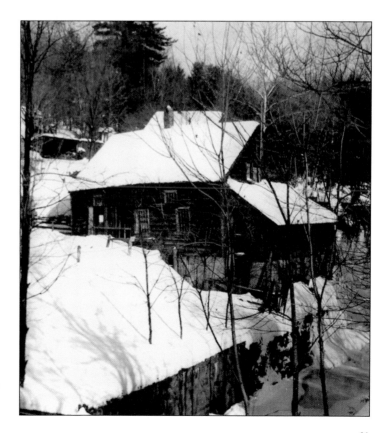

Here we see Cox's Mill and waterfall covered by ice and snow.

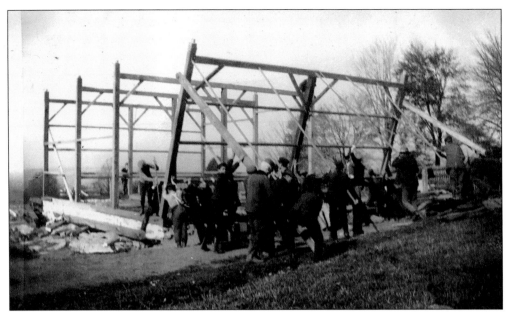

This *c.* 1920 photograph shows a barn-raising in Paynetown, the area near the junction of Middle Haddam Road and Portland-Cobalt Road (Route 66).

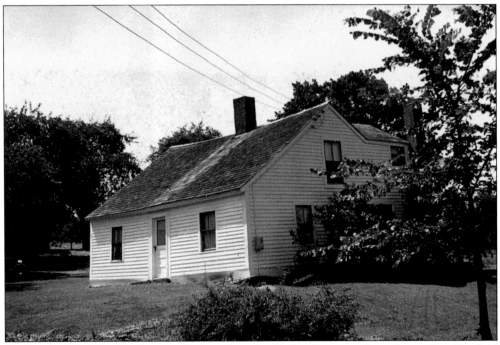

The *c.* 1740 S. P. Hurlburt house, also known as the Kuskey homestead, was located on Penfield Hill Road just south of Stephen Tom Road on the west side.

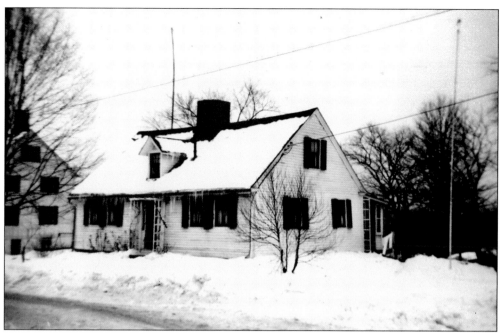

This c. 1750 house, located at 3 Indian Hill Avenue, was built on the land of the Wangunk Indians by Job Bates, perhaps as much as 20 years before the land was officially sold to the settlers in 1765. Bates was married to Faith Doty in the spring of 1747 in Wareham, Massachusetts, where they both lived; the two then remarried in Middletown on October 15, 1747, perhaps as a statement to their new community that they were indeed married.

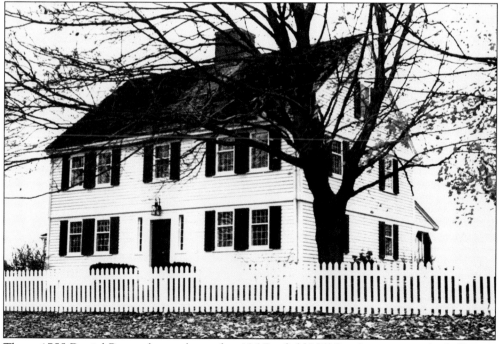

The c. 1755 Daniel Burton house, located at 126 Penfield Hill Road, is a two-and-a-half story, center-chimney Colonial with the classic double overhang of the New England Colonial.

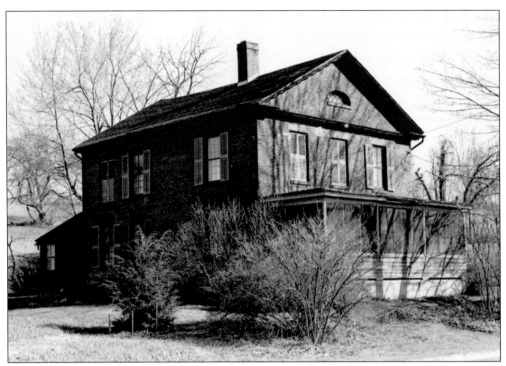

The c. 1830 Noah Strickland house, a gable-to-street Federal-style house, was built of locally fired brick. The Stricklands were local brickmakers. Although the house itself has not moved, its address has changed from 375 Strickland Street to 375 Gospel Lane. During the 1936 flood, the water on the first floor of this house was four feet deep.

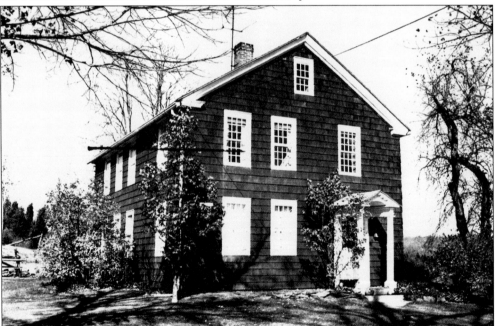

The c. 1828 Alanson Hurlbut house, a simple Federal-style home located at 238 Cox Road, shows how the style evolved from the Colonial.

64

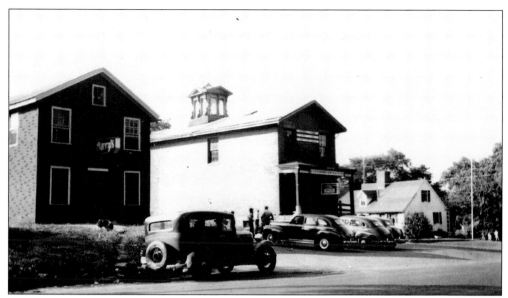

This photograph, taken in the late 1940s, shows Harry's Tavern at 642 Main Street, the cupola-topped Gildersleeve store and post office at 646 Main Street, and Phillip Gildersleeve's house at 3 Indian Hill Avenue.

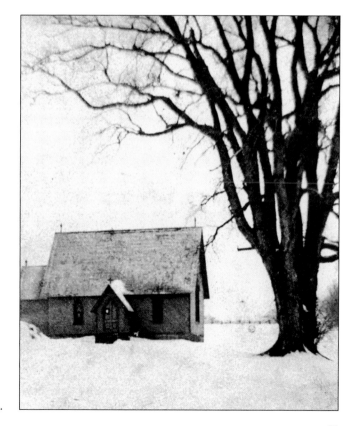

St. John's Chapel was located at the corner of Gospel Lane (formerly Strickland Street) and Cox Road. Services were held here from 1870 until 1965, when the building was deconsecrated and demolished.

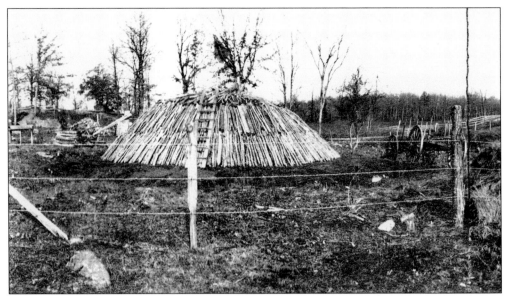

This old-fashioned method of making charcoal is considered today to be quite inefficient, but in the old days, making a charcoal pit was really a work of art. Will Kelsey (seen in the cover photograph) operated this charcoal pit in the late 19th century and early 20th century at a location just east of where Kelsey's Pond is now.

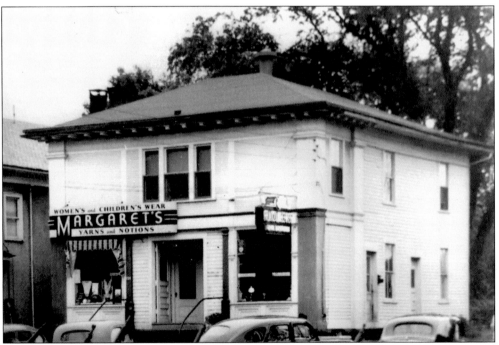

This building at 258 Main Street was built by 1896. Formerly the Young Emerald's Hall, it served as the Post Office from 1898 to 1941. Margaret's Department Store opened here in 1946.

Four

DEPARTMENT
OF TRANSPORTATION

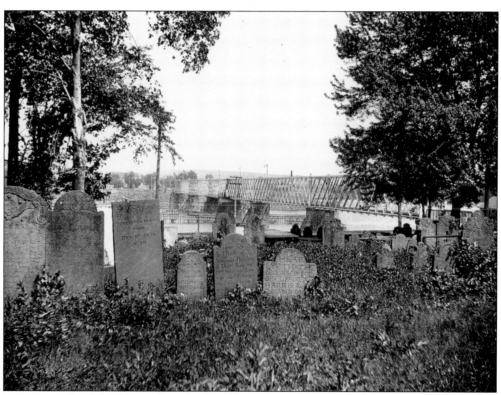

The first railroad bridge can be seen here from the old Riverside Cemetery in Middletown. Portland's earliest residents were buried here before a parish was established on the east side of the river.

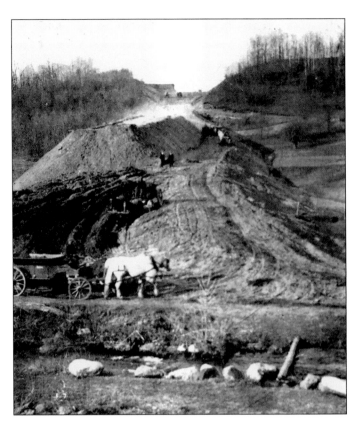

This 1920s image, looking up Wilcox Hill, shows the construction of the Portland-Glastonbury Highway, now known as Glastonbury Turnpike or Route 17.

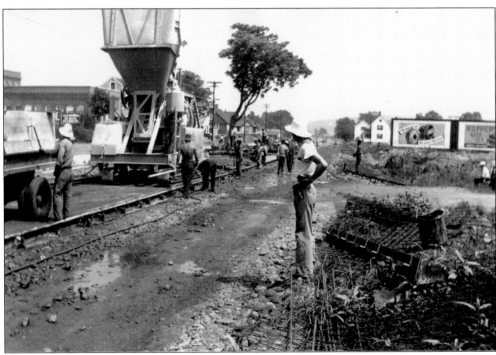

This photograph shows Marlborough Street under construction c. 1940.

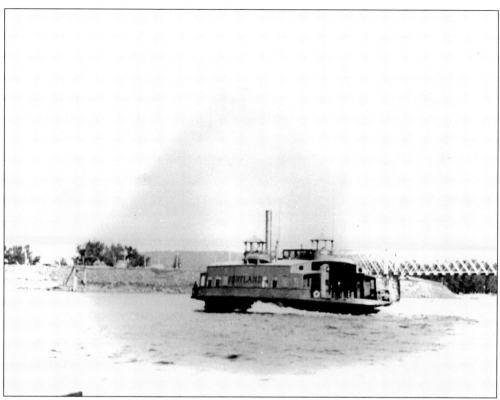

The ferry boat *Portland* transported highway traffic across the river between Middletown and Portland until 1896, when the first highway bridge was built. The 1872 railroad bridge can be seen in the background.

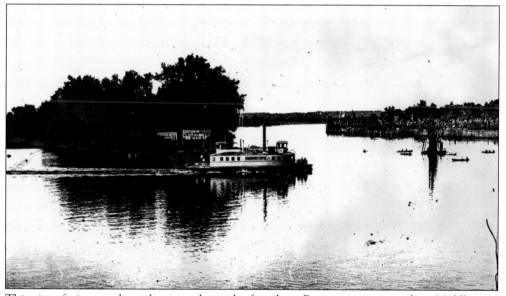

This view, facing north up the river, shows the ferry boat *Brownstone* crossing from Middletown to Portland. Billboards can be seen on Willow Island. The brownstone quarry operation is evident along the Portland shore.

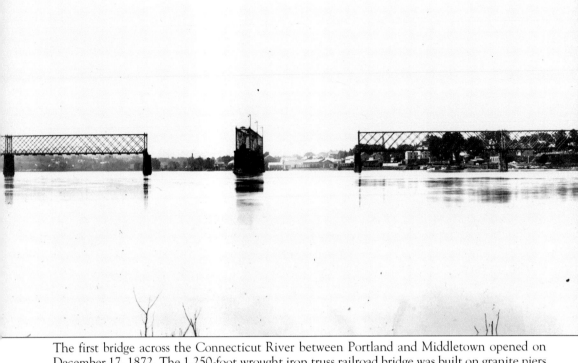

The first bridge across the Connecticut River between Portland and Middletown opened on December 17, 1872. The 1,250-foot wrought iron truss railroad bridge was built on granite piers from the quarry near Collins Hill. This photograph shows the Middletown-Portland Railroad Bridge about 1885. The current railroad bridge rests on the same piers.

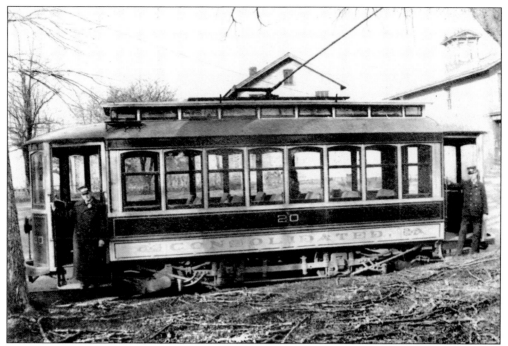

The trolley *Portland* is seen here in front of the Gildersleeve Store. After the opening of the Middletown-Portland Bridge in 1896, little time was wasted in laying trolley tracks across the bridge into Portland as far as Gildersleeve. Trolley operation ceased in 1929, but the convenience of the service is remembered fondly by many of the older residents.

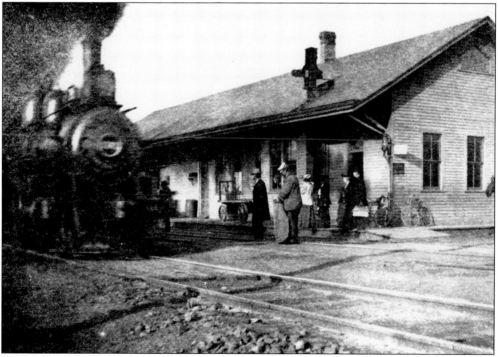

Here we see the *S. 34* pulling into the train station on Marlborough Street in Portland.

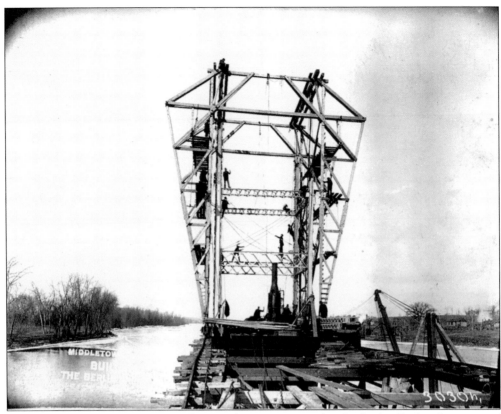

The first highway bridge is shown here under construction by the Berlin Bridge Company of East Berlin on January 18, 1896.

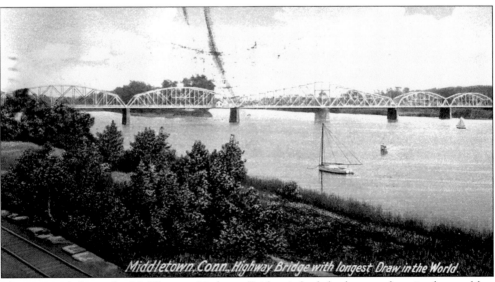

This postcard shows the Middletown Highway Bridge; it had the longest draw in the world at the time that it was built.

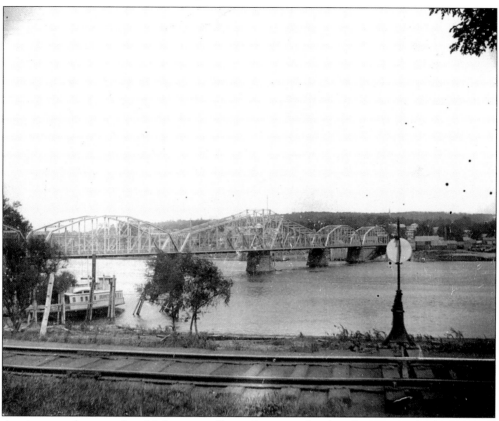

As time marches on, the old ferry sits idle at the riverside after the new bridge had opened in 1896.

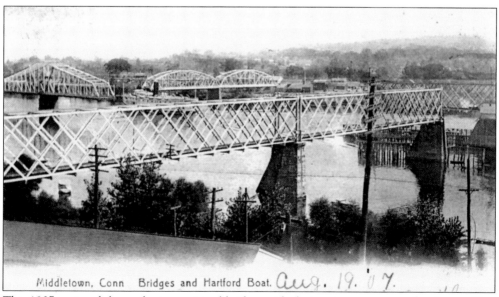

Middletown, Conn Bridges and Hartford Boat. Aug. 19. 07.

This 1907 postcard shows the two original bridges with their swing spans open for river traffic.

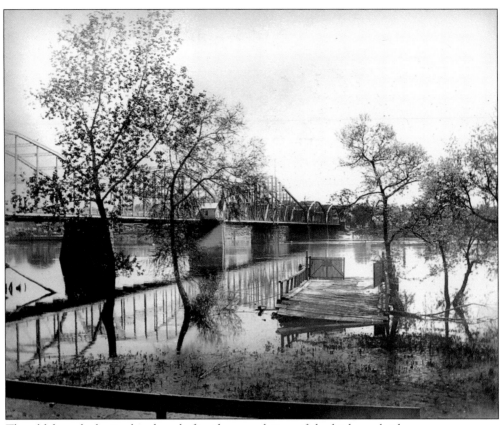

The old ferry dock sits abandoned after the completion of the highway bridge.

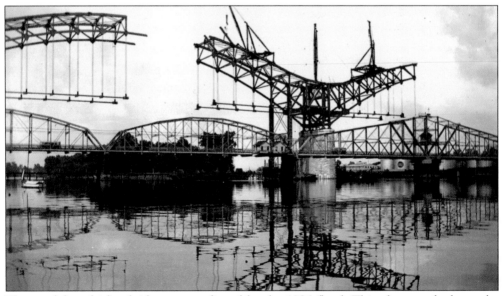

The need for a higher bridge was confirmed by the 1936 flood. This photograph shows the Middletown-Portland Bridge under construction.

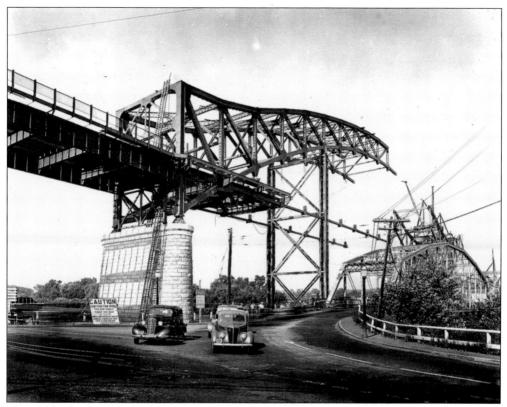

The old bridge remained in service throughout the construction of the new highway bridge.

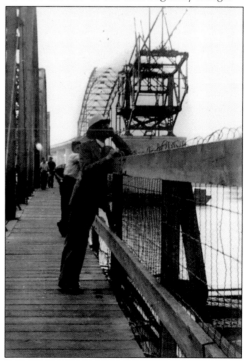

Rev. F. L. Streeter, pastor of the Methodist church, watches construction of the new bridge from the pedestrian walk on the old bridge. The Middletown span can be seen in the background.

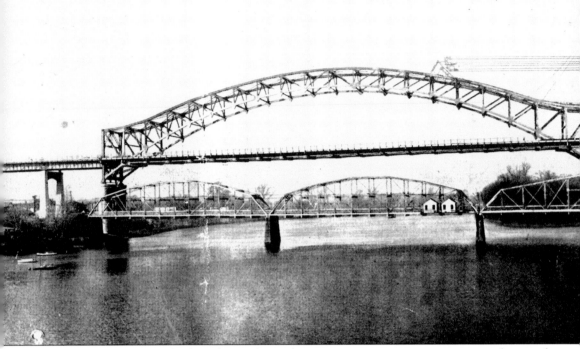

The Middletown-Portland Bridge is shown here as construction crews near completion of the Portland span of the bridge. Construction began in 1936 and was completed in 1938. The bridge was built at a cost of $3.5 million and was hailed as the largest bridge in New England. It opened on August 8, 1938. Two-thirds of a mile long and connecting Middletown and Portland, the bridge was built to replace the 1895 highway toll bridge and is the state's

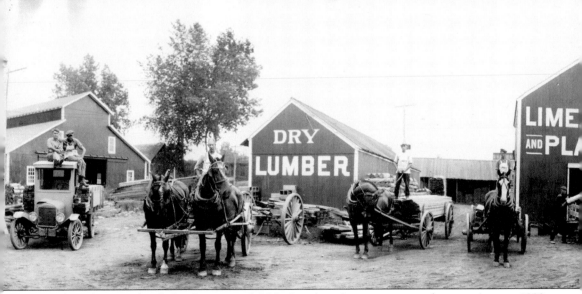

This photograph of the Strong and Hale Lumber Company was taken in August 1922. The following employees are identified on the back of the photograph: executives John C. Barry, John A. Dodd, Alfred Dodd, J. Harold Barry, and Ruth Bostrom; teamsters John E. Barry,

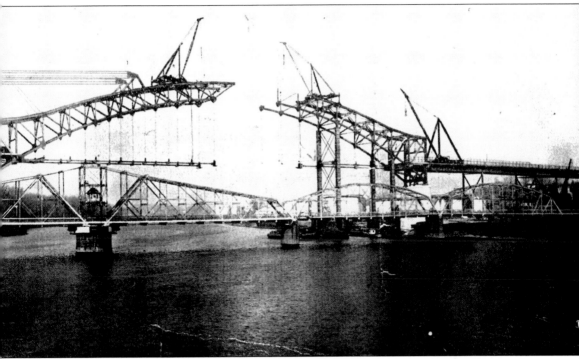

only major cable-suspension bridge. Its 1,300-foot-long, two-lane plank drawbridge can be seen in the foreground. Beginning in 1989, the bridge underwent major structural repairs and repainting. The bridge has about 1.5 million square feet of painted steel; in 1995, the cost of painting it was $6 million.

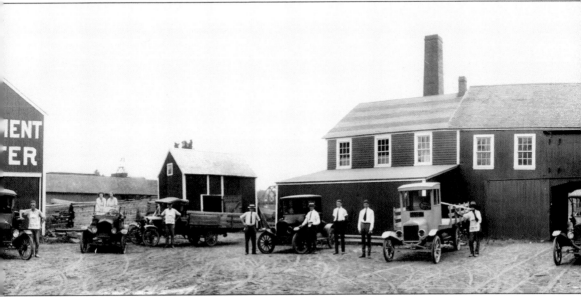

Bill Daly, and Ed Hyatt; and truckers Jim O'Connell, William Sanders, Carl Bengston, and Martin M. Also pictured are Rev. M. Brodis and J. Cosgrov. This photograph can be seen on the wall of the lumber company office on page 83.

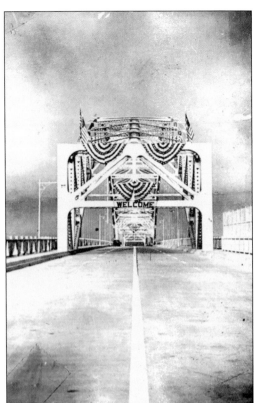

In this view, looking west toward Middletown, the new bridge is decorated for opening day. Notice the containment fence over the right railing to protect the oil tanks. There was, however, no railing between pedestrians and traffic.

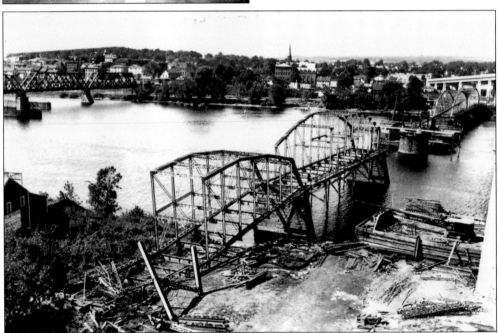

After the new bridge was opened, the old highway bridge was no longer needed. This photograph, taken from the Portland side of the Connecticut River, shows the old bridge as it was being dismantled.

Five

INDIVIDUALS
AND ORGANIZATIONS

Here we see 3-year-old E. Irving Bell Jr. in a photograph taken at Pres. Teddy Roosevelt's inauguration in Washington, D.C., and reproduced on this postcard. E. Irving Bell Jr. was the son of E. I. Bell, who organized the Connecticut Steam Brownstone Company to saw and cut stone and carve it to architects' specifications.

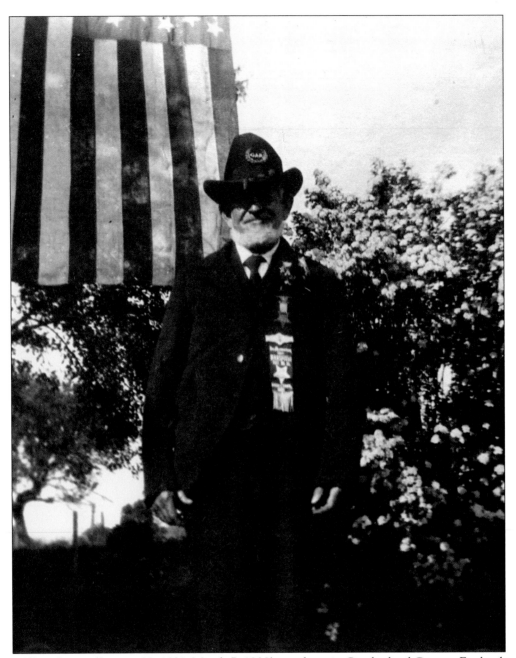

William Jaques (January 29, 1831–March 7, 1908), was born in Cumberland County, England, where he learned stonework from his father. He came to America in 1853 and worked in the Middlesex Quarry in Portland. In March 1861, he joined Captain Sawyer's Company H. 9th Regiment of the Connecticut Volunteer Infantry as a private to fight in the Civil War. He returned to Portland in 1865 and spent the rest of his life here. His granddaughter was Elizabeth Leigh Dagnall.

John Cordell "Dell" Reeves (August 1, 1848–August 7, 1933) was known throughout the state as a hunter, trapper, fisherman, and rattlesnake hunter. He captured hundreds of rattlers, and his fame as a hunter of snakes spread throughout the country. Reeves was the first superintendent (or state forester) when the Portland Forest was established in 1903.

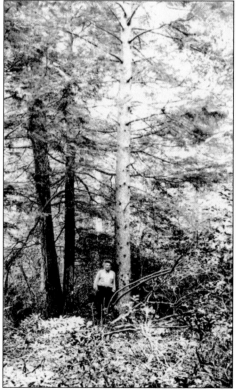

Joseph P. Synnott is shown here in 1932 with a red spruce measuring 16 inches in diameter and 75 feet high. Synnott was the district forest fire warden. The Portland Forest, established in 1903, became the Meshomasic State Forest in 1921. It was the first state forest in New England and the second in the country.

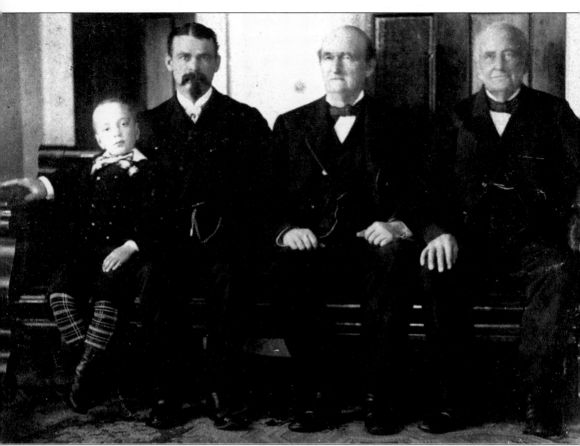

Four generations of Gildersleeves are shown here c. 1877. Pictured, from left to right, are Alfred Hall Gildersleeve (1872–1930), Oliver Gildersleeve (1844–1912), Henry Gildersleeve (1817–1894), and Sylvester Gildersleeve (1795–1886). Sylvester Gildersleeve was the enterprising shipbuilder who consolidated several Portland shipyards to establish the famous S. Gildersleeve and Sons, which built and launched 358 vessels between 1821 and 1932. The yard was located on Shipyard Lane, now known as Indian Hill Avenue. In 1776, Sylvester's grandfather Obadiah Gildersleeve fled from Sag Harbor, Long Island to Portland with his wife and eight children and all the goods they could ship during the British invasion. He was a boss carpenter on shipbuilding contracts, and he worked in New Haven and Portland until he was joined by his son Philip, who had fought in the Battle of Long Island. Together they opened their own shipyard.

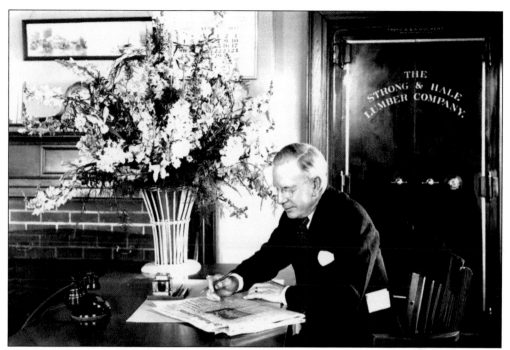

John C. Barry, president of the Strong & Hale Lumber Company, is shown here on April 25, 1937, during the company's 55th anniversary.

Frederick DePeyster (wearing the derby hat) stands in front of his home at 333 Main Street greeting Reverend Raftery (in the horse-drawn buggy). The little girl is Anna DePeyster, who eventually married into the Gildersleeve family.

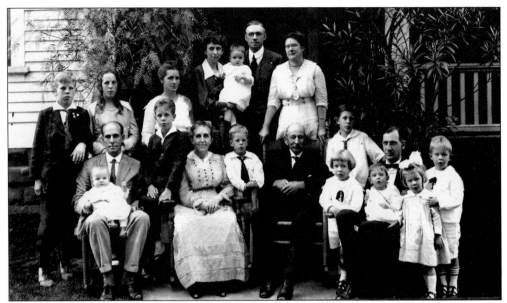

The Goodrich family is pictured here in 1919. At the front left is Herbert W. holding his son Richard; son Wells is to his right, and behind him, from left to right, are son Burton, daughter Janet, and wife Alice. In the front center are grandparents Ella and Fred W. on either side of Stanley, son of Herbert and Alice. At the right is Fred R. with his children, from left to right, Fred W. II, Norman, John, Dorothy, and Robert. In the back center are Nell and Dan Wilkins with their infant daughter Mary Louise. The woman in white at the back right is Bertha Goodrich, wife of Fred R.

This photograph was taken on Memorial Day 1948 in front of the town hall. Pictured, from left to right, are the following: unidentified (hidden behind the flag), Stanley Florkoski, Robert Olson, Raymond Hedges, Reginald Hummel, Arthur Towner, unidentified, Andres Anderson, William Olson, Arthur Peterson, and Norman Hanson.

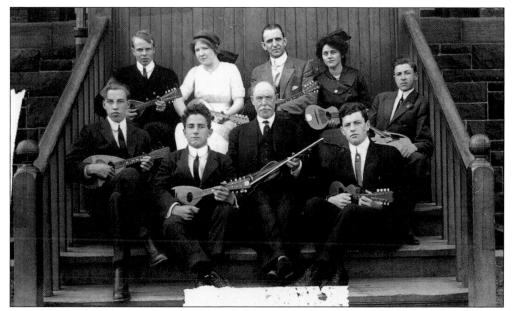

The Mandolin Club of Portland sits in front of the high school c. 1915. George Marsh (born in 1898) is on the front left, and Ellen Johnson is in back on the right. The woman in white is a Gustafson.

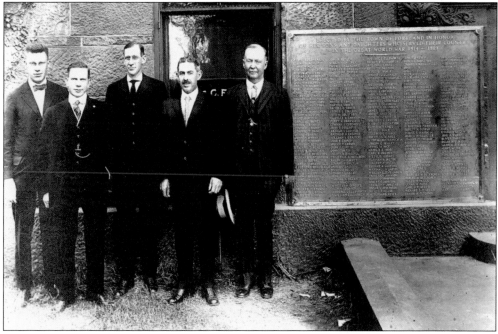

The Portland War Bureau is pictured here in front of the Portland Town Hall at the dedication of a memorial plaque. The plaque reads, "Erected by the town of Portland in honor of her sons and daughters who served their country in the Great World War 1914–1919." Shown here, from left to right, are David Carlson, John C. Barry, Frederick R. Goodrich, Harry Howard, and Fred DePeyster.

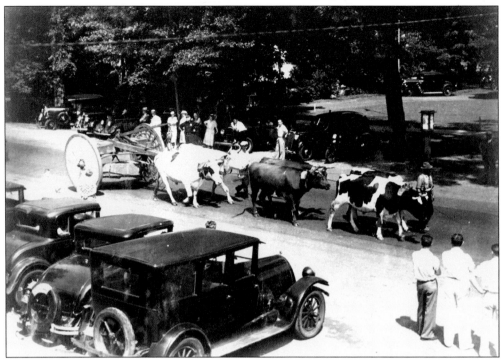

A three-team hitch of oxen are shown here pulling the arch down Main Street with a sling of brownstone in the Connecticut Tercentenary Celebration parade, held on June 29, 1935.

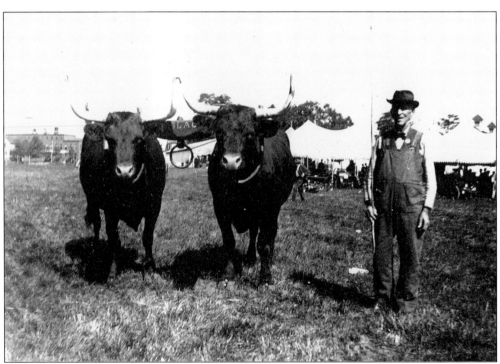

This postcard shows Grandpa Penfield in his 76th year with his premium cattle at the Berlin Fair.

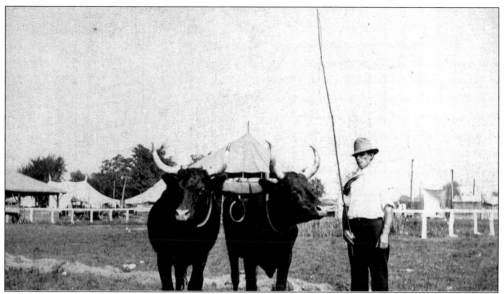

Bill Farrell of Breezy Corner Road is shown here as a young man at the Portland Fair with his team of oxen.

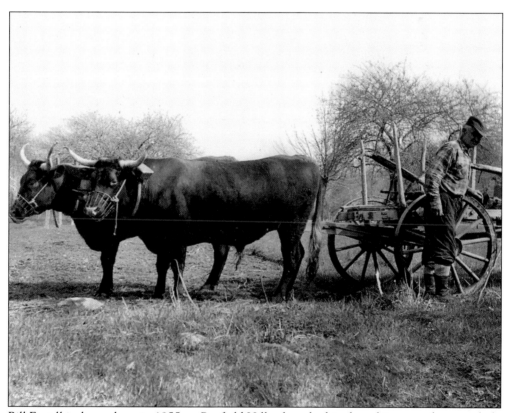

Bill Farrell is shown here in 1955 on Penfield Hill, where he hired out his team of oxen to help clear a building lot. On Sunday, September 3, 1950, the *Hartford Courant* reported that Farrell had been exhibiting oxen at the Woodstock Fair for more than 50 years.

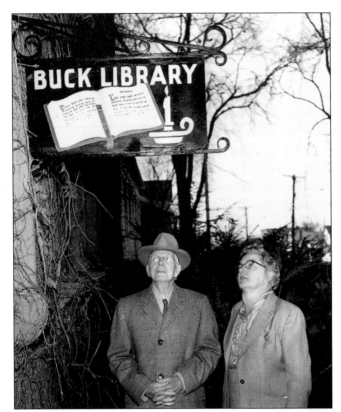

John C. Barry and Marion Wannerstrom, librarian, are shown in front of the Buck Library building at 261 Main Street. The library was named for Horace Buck, born in 1822 in the area known as Bucktown. Because his three children had died, no one would carry on his name. He wanted the building in Portland, the town where his children were buried, to carry the Buck family name. He donated $2,500 toward the building of a library shortly before his death in 1896, and he left another $2,500 to this library in his will.

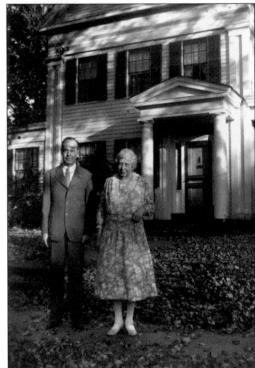

Mrs. DePeyster and her son Fred are pictured in front of her home at 333 Main Street, now the site of the Portland Convalescent Centre.

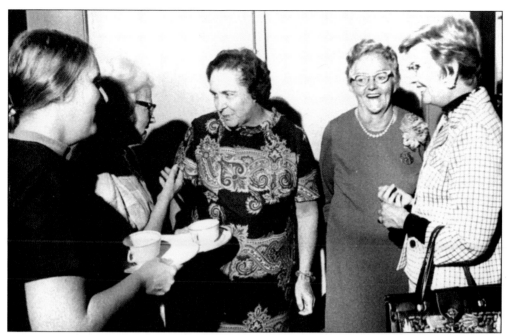

Mary Flood and Marion Wannerstrom, librarians at Buck Library, are shown here in 1971.

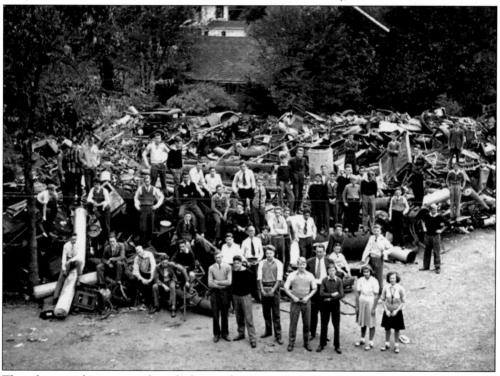

This photograph gives an idea of what enthusiastic young people can do during a war effort. Portland High School students amassed about 110 tons of scrap metal. The metal shown here was piled at the rear of Portland's town hall. In the foreground, committee chairmen are pictured with Superintendent of Schools John Goodrich.

Ruth Ryan Callander bequeathed her home at 492 Main Street to the Portland Historical Society to be used as a museum of Portland history.

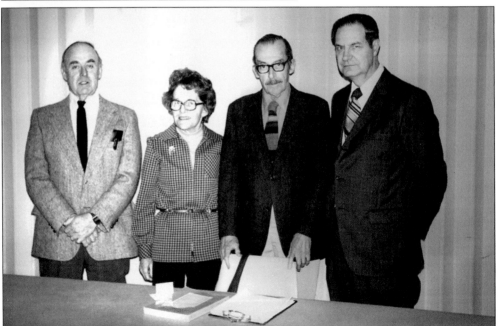

The Portland Historical Society was organized in 1974. The founding officers, pictured here from left to right, were Herbert M. Ellsworth, president; Ruth Hale, secretary; James Gildersleeve, vice president; and Albert LeShane, treasurer.

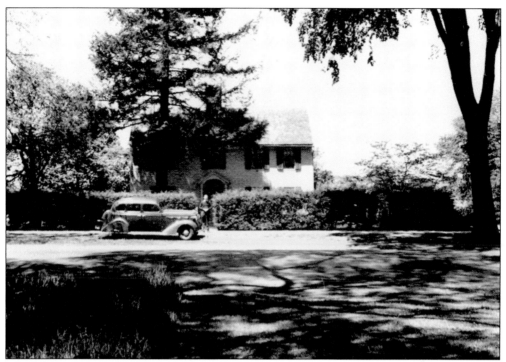

The White-Overton-Callander house at 492 Main Street is pictured here in the 1940s.

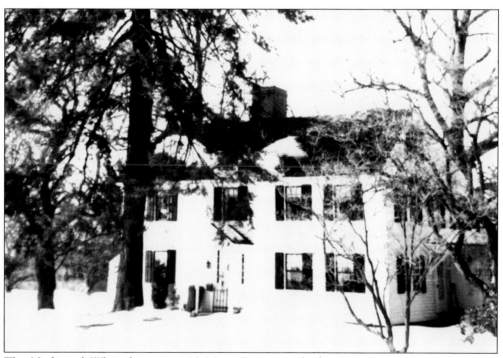

The Nathaniel White house at 492 Main Street was built c. 1711. By 1810, it had been extended across the back, creating a room that housed the well. It is now known as the Ruth Callander House Museum of Portland History.

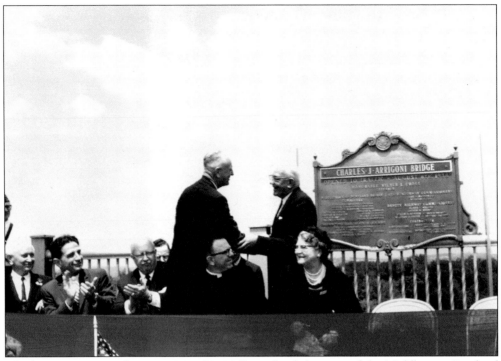

Charles J. Arrigoni is shown on May 30, 1963, at the dedication of the Middletown-Portland Bridge in his honor.

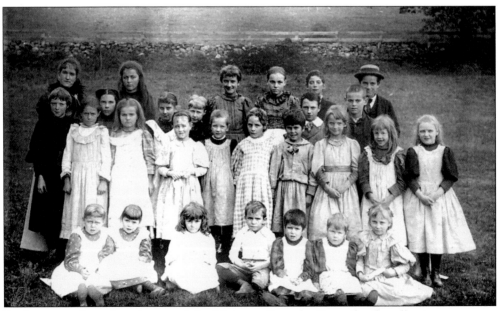

Students pose for a class photograph in this image from the Payne family collection.

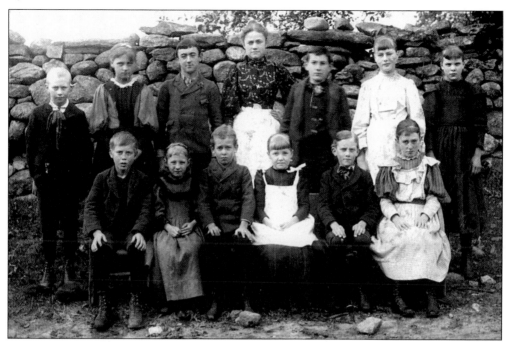

This photograph shows John Payne and his classmates at the Penfield Hill School in 1895. The Penfield Hill School was built in 1830, and an addition was built in 1840. Many prominent families in the outlying sections had children who attended this school. Most notable among them was the Payne family, which has resided in what is now the town of Portland since the 17th century. Silas Payne had his education in the district school at Penfield Hill, which at the time was one of the largest schools in town. The Penfield Hill School closed in 1920, when the Freestone School opened its classrooms. In later years, the building was purchased and taken over by the Noyes Camp, which owns the adjoining property.

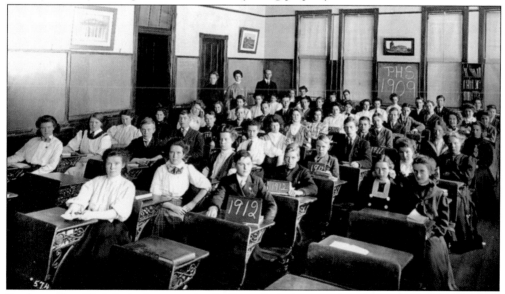

Students identified their class years in chalk on their slates in this photograph of the Portland High School classes of 1909,1910, 1911, and 1912.

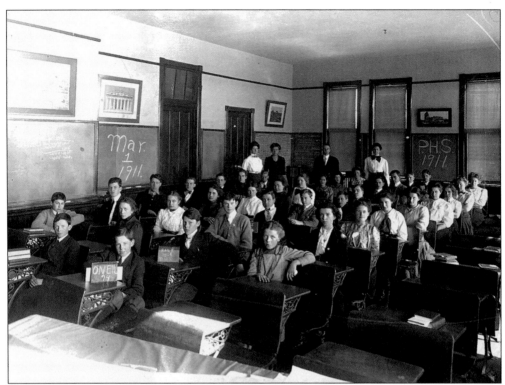

This photograph shows the Portland High School classes of 1911 through 1914. Students O'Neil and Hale of the class of 1914 identify themselves with chalk on their slates.

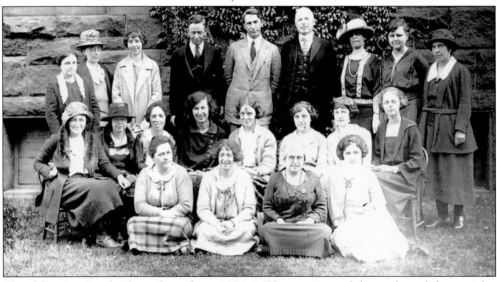

The following Portland teachers from 1922–1923 are pictured here, from left to right: (first row) two unidentified people, Lillian Aston, and Miss Mayo; (second row) unidentified, Jessie Cone, unidentified, Estelle Walsh, Beatrice Howard, unidentified, Marion Baldwin, and Ms. Harrington (the music teacher); (third row) Lulu Strickland, Mary C. Lewis, Ida Bantell, Mr. Kehoe, Mr. Barbour, John D. Secord (the first principal of the high school when it moved to 314 Main Street in 1931), Jessie Chapman, Florence Parmellee, and Helen Cornwall.

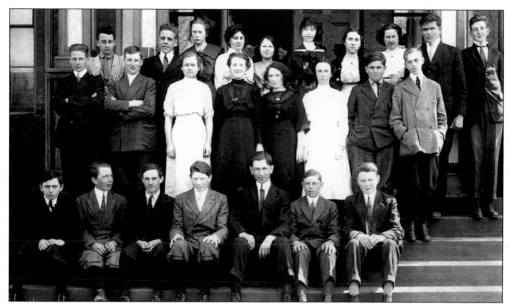

This Portland High School class of 1915 freshman photograph was taken in 1911 on the steps of Central School. Pictured, from left to right, are the following: (first row) Walter Werdelin, Oliver B. Ellsworth, Howard B. Goodrich, Daniel Curtin, Richard Forsburg, S. Milton Whitby, and Nelson Shepard; (second row) Clarence C. Ellsworth, Lee Whittles, Hedwig Anderson, Margaret Mitchell, May Callahan, Elizabeth McAuliffe, Truman Hale, and Dudley Marsh; (third row) Earl Penfield, Edwin Nyman, Josephine Olsen, Ruth Bartlett, Catherine Olszewski, Marion Gildersleeve, Catherine Quigley, Helen Lynch, Harry L. Hale, and Elliott F. Keser.

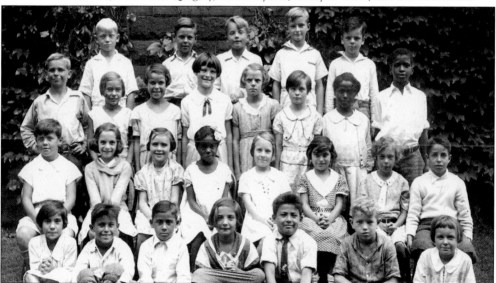

Seen in this 1935 Central School class photograph are, from left to right, the following: (first row) unidentified, ? Mendello, ? Mendello, two unidentified people, Bill Foley, and Doris Ahlberg; (second row) Ernie Peterson, Catherine Csere, two unidentified people, Grace Johnson, and three unidentified people; (third row) unidentified, Nellie Sandstrom, unidentified, Shirley Marks, unidentified, ? Branch, and two unidentified people; (fourth row) Clifford Eckstrom, two unidentified people, Warren Jackson, and unidentified.

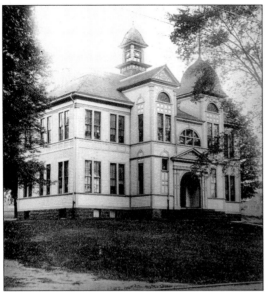

This school was built in 1889 to replace the original Gildersleeve Hall School that was built in 1876 and destroyed by fire in 1889. Used as a public school building until 1959, it was demolished in 1963 to make room for the opening in September 1964 of the third school on the same site.

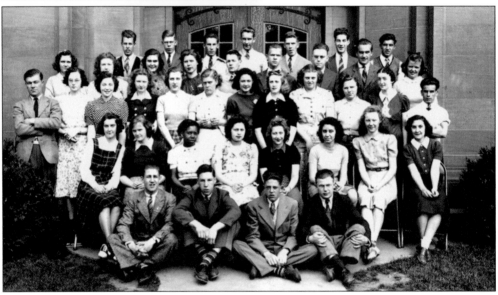

In 1941, the year that the town of Portland celebrated its 100th anniversary, the senior class graduated on June 20. Members of the class, seen here from left to right, are the following: (first row) Howard W. Ostergren, James P. Quirk, Charles Wannerstrom, and John E. Anderson Jr.; (second row) Clara M. White, Roberta Nickle, Alma M. Jackson, Jeanette L. Rozowoda, Violette A. Clark, Phyllis Eisenstein, Anna R. Maher, and Lillian E. Natale; (third row) Thomas E. Coates, Hazel Robinson, Theodora E. Lucas, Mariday Abbey, Beverly M. Ellsworth, Regina M. Grzegorowicz, Janet L. Ablehauser, Anita P. Keane, Gladys V. Oakliff, Marian C. Cashman, Emma Alfreda Wilcox, and Sebastian Lastrina; (fourth row) Shirley E. Ives, Irene G. Walsh, Elsie M. Hale, Shirley Hall, Alden Roman, Joseph E. Klim, Douglas C. Prout, Robert Iverson, and Margaret H. Wannerstrom; (fifth row) Donald B. Kelsey, Warren L. Soneson, William J. Reiman, Raymond F. Hetzel, John Bransfield, William F. Csere, and Joseph Morariu. Also graduating, but not shown in the photograph, were Helen P. Gustafson, Marshall V. Fogelmark, and Douglas Hale.

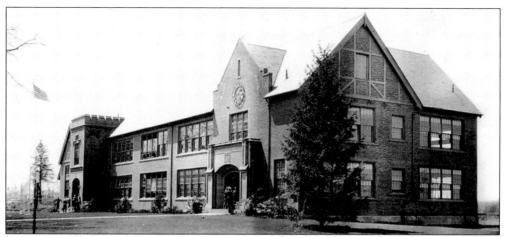

The Portland Junior Senior High School opened in 1932 to accommodate grades 7 through 12. With its modern accouterments, this building put the town school system squarely into the 20th century. A 400-seat auditorium; a gymnasium with lockers, showers, and dressing rooms; science laboratories; domestic arts facilities; and much more made this a school of which the town could be proud. With additions in 1953 and 1967, it was later known as the Portland Junior High School and then the Portland Middle School, serving grades 6 through 8. This school will soon be renamed the Brownstone Intermediate School and will serve grades 5 and 6.

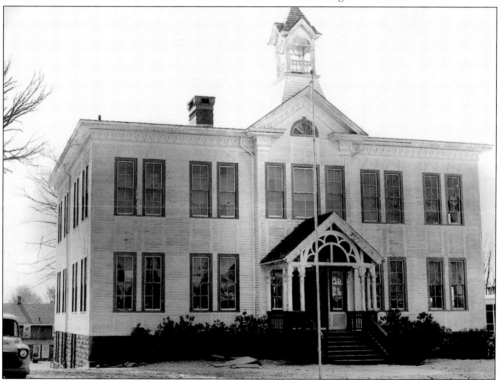

St. Mary's Convent School was built in 1890 and dedicated on Thanksgiving Day, November 27, 1890. It cost $11,500 to build and had eight classrooms and a full cellar. The 70- by 57-foot building, located between the church and the convent, was set back from the street. In 1900, the school had 178 pupils. It was demolished after the new school opened on January 5, 1959.

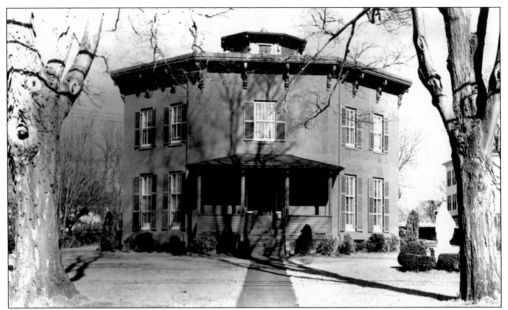

Gilbert Stancliff acquired this lot and had this octagon built in 1854. Stancliff was a sixth-generation descendant of Portland's first settler, James Stancliff. The Stancliff family retained this property until 1929. St. Mary's Roman Catholic Church owned this house and used it as a convent from 1955 through 1975. The house is flanked by the Joseph Williams octagon to the west; they are rumored to be the only twin octagons in the world.

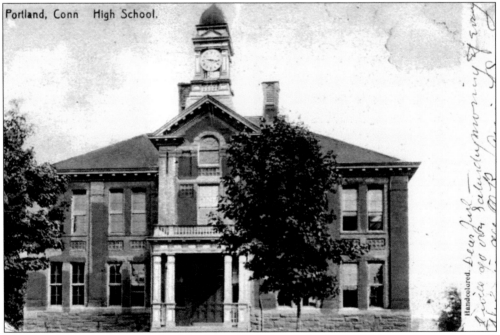

This postcard of the high school built in 1888 shows the beautiful brownstone and brick two-story building, which featured terra cotta insets and a stately clock tower. This was a school building from 1889 to 1979 and was commonly known as Central School. After extensive renovation, it became the town hall in 2001.

This photograph shows the Lutheran church on Waverly Avenue as it appeared in 1941.

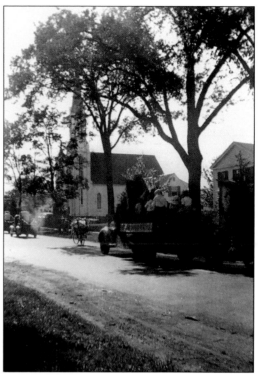

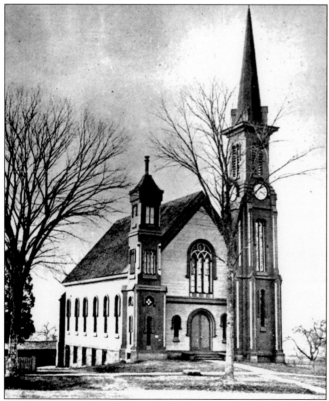

The Congregational church in Gildersleeve is the oldest church edifice in town. This photograph shows the Gothic style of architecture popular at the time of its construction in 1850. Damage from the hurricane of 1944 made it necessary to make structural repairs and architectural renovations, which changed the appearance of the church.

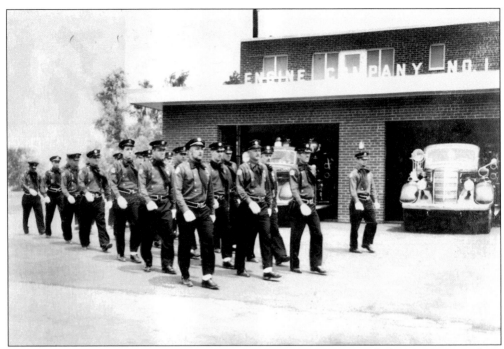

The Portland Volunteer Fire Department's Engine Company No. 1 Drill Team is shown in front of the firehouse at 7 Middlesex Avenue, which opened in 1959.

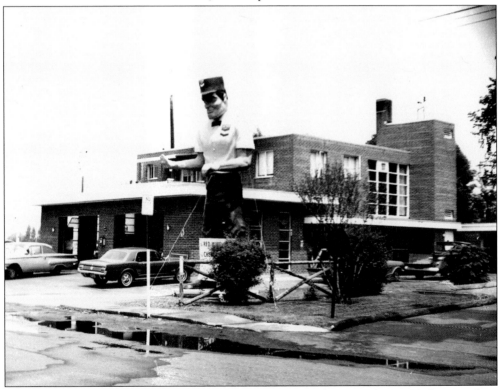

Engine Company No. 1's firehouse on Middlesex Avenue is shown in this 1966 photograph.

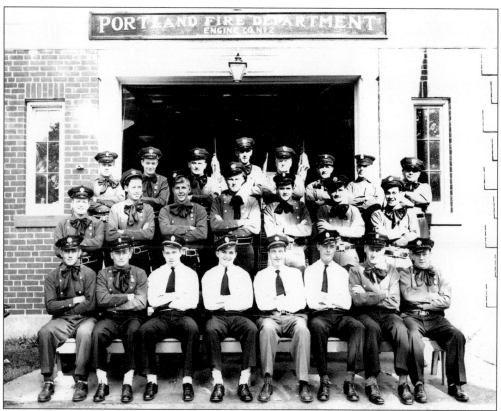

Members of Engine Company No. 2, pictured here *c.* 1946-1950, are, from left to right, the following: (first row) Francis Debari, Henry Basso, Robert Baines, Charles Hale, Philip Gildersleeve, Ralph Barrett, Joseph Basso, and Romeo Courlard; (second row) Edward Leffingwell, Edward Barrs, William Nelson, Robert Larson, Robert German, Albert Wychrowski, and Charles Atone. Among the men in the third row are Earl Johnson, James Post, Felix Basso, John Abbey, Aubrey Henderson, Harry Brooks, and Andy DeGraff.

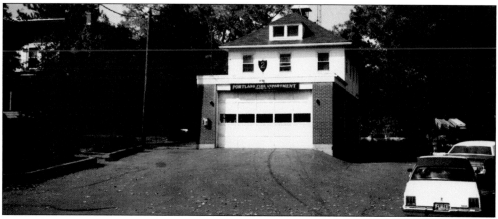

The firehouse of Company No. 2, located on Main Street in Gildersleeve, is seen here in 1985. It has since been replaced by a larger building at the corner of Bell Court. This building housed the police department until 2003, and it is currently being renovated by the Connecticut Cellar Savers to serve as a fire museum.

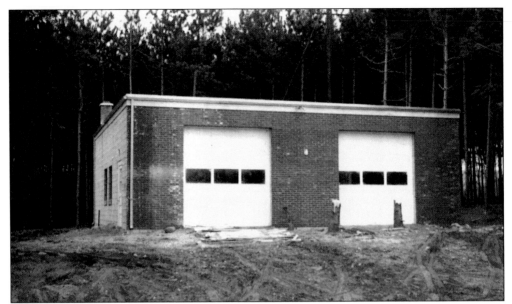

The firehouse of Portland Volunteer Fire Department Company No. 3, located on Great Hill Road, was newly constructed in this 1964 photograph. Notice the stump still in front of the door.

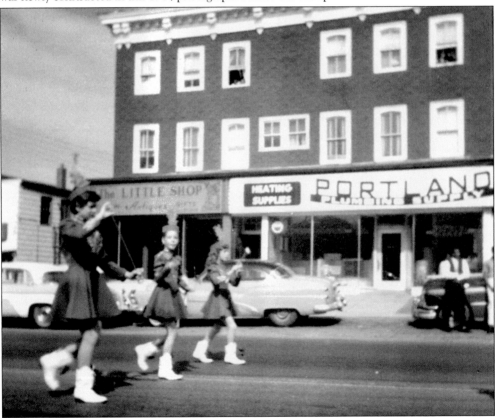

This photograph shows the Memorial Day parade on May 30, 1960. The Palmer Block at 208 Main Street is in the background.

Six

SHIPYARDS AND QUARRIES

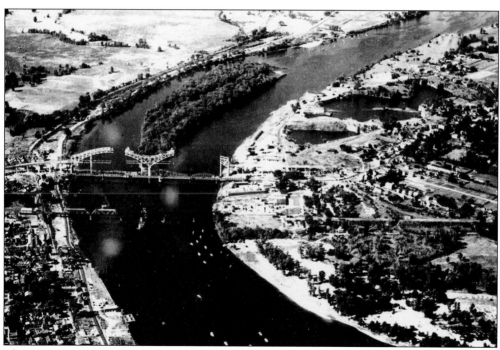

This aerial photograph, looking north up the Connecticut River, shows the big bend in the river that makes Portland easy to find on a state map. The famous brownstone quarries can be seen to the right of the island, on the east bank of the river. The Gildersleeve section of town, famous for its shipyards, is about two miles north on the eastern shore of the river. This photograph shows the Arrigoni Bridge under construction in 1937.

THE
GILDERSLEEVE SHIP CONSTRUCTION CO.

REQUESTS THE HONOR OF YOUR PRESENCE

AT THE LAUNCHING OF THE

STEAMSHIP "BATTAHATCHEE"

FOR THE

UNITED STATES SHIPPING BOARD
EMERGENCY FLEET CORPORATION

SATURDAY, OCTOBER FIFTH

NINETEEN HUNDRED AND EIGHTEEN

AT ONE O'CLOCK

SPONSOR

MISS MARIAN H. GILDERSLEEVE

This was the invitation to the launching of the *Battahatchee*. The next three photographs show the ship under construction in 1918. On Saturday, October 5, 1918, Marion H. Gildersleeve—daughter of the president of the Gilderseleeve Ship Construction Company, Alfred Gildersleeve—christened the ship *Battahatchee*, an American Indian name selected by Edith Wilson, wife of Pres. Woodrow Wilson.

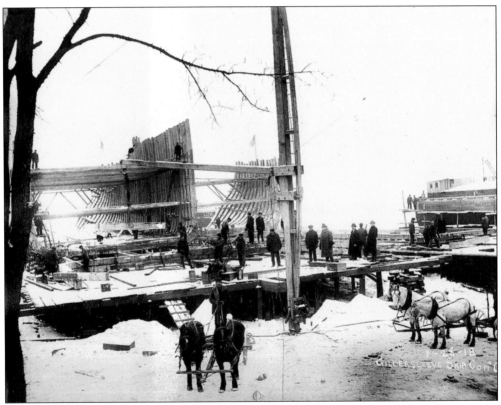

On January 28, 1918, the Gildersleeve Ship Construction Company's shipyard workers pose by the *Battahatchee*, one of the ships constructed for World War I. These frames were fashioned from native timbers cut in the steam mill on the site. A bronze plaque mounted on a block of brownstone marks this site on the north side of Indian Hill Avenue.

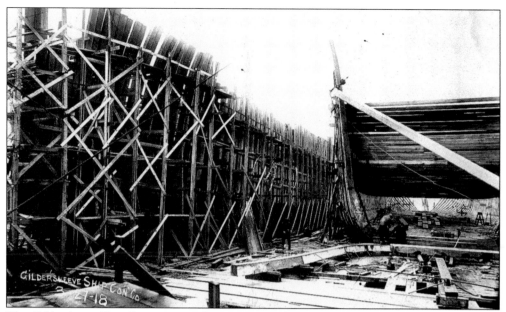

The Gildersleeve Ship Construction Company, seen here on March 27, 1918, was strategically located on the Connecticut River at the Portland Meadows, an ideal location for shipbuilding. The location was utilized by many enterprising shipbuilders, including Lewis, Churchill, and White, during the 18th century. In the 19th century, Sylvester Gildersleeve consolidated several yards to establish S. Gildersleeve and Sons. The Gildersleeves built and launched 358 vessels between 1821 and 1932.

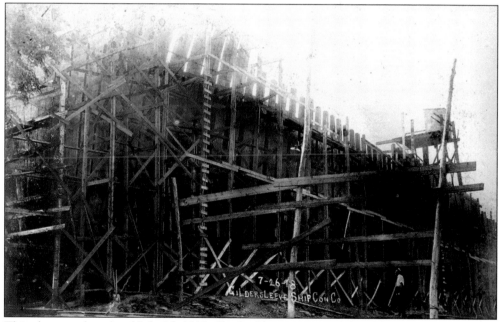

This photograph is dated July 26, 1918. Shipbuilding was one of the oldest industries in town; the first ship was built here in 1741. From 1821 (when the first ship was built here by Sylvester Gildersleeve) through 1916, the Gildersleeve shipyard had built a total of 292 seagoing craft of various types. Shipbuilding ceased here in 1932.

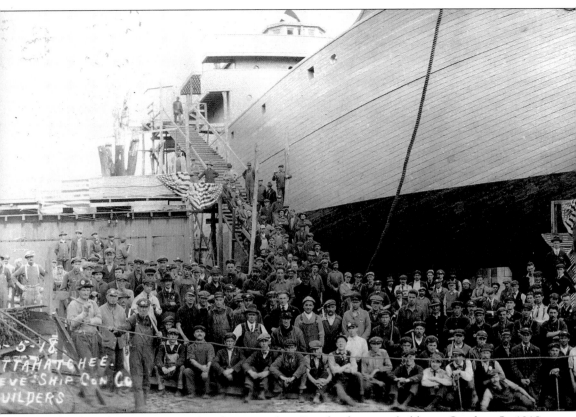

The launching ceremony for the steamship *Battahatchee* was held on October 5, 1918. The *Battahatchee*, weighing 3,600 tons, was the largest steamship ever built by the Gildersleeve

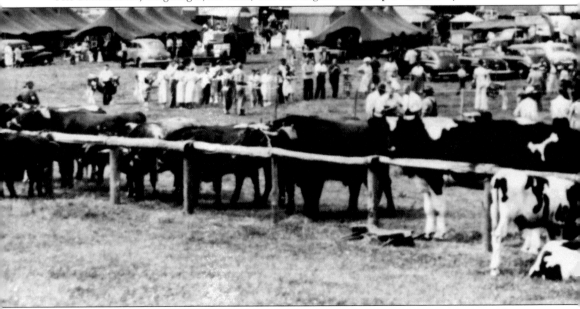

Oxen contributed significantly to the quarrying operation. In a 1931 town meeting, the town voted to build a six-year high school. A building was planned and built in less than a year on the

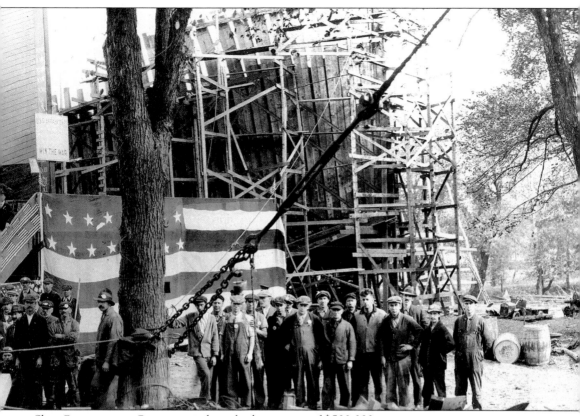

Ship Construction Company and was built at a cost of $500,000.

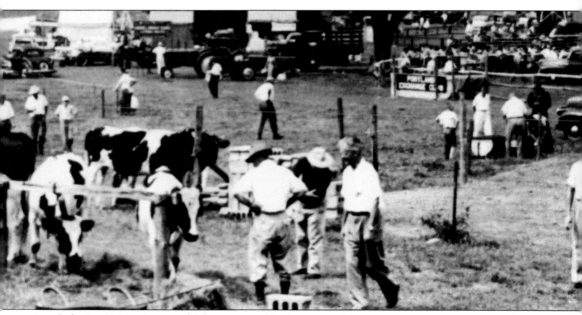

"cattle lot" on Main Street, which was probably the place where the quarry oxen were kept This
photograph shows cattle at the Portland Fair in 1951 on Prout Acres, located next to that spot.

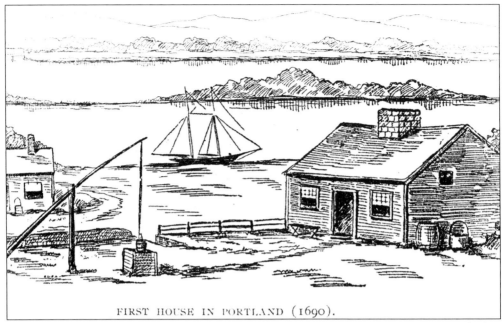

FIRST HOUSE IN PORTLAND (1690).

The earliest industry in Portland was the quarrying of brownstone from the immense supply that was found here. There has been much speculation as to who was the first to engage in quarrying, but it is commonly thought to be James Stancliff, an English stonecutter. On May 2, 1690, he purchased a 20-rod-square parcel of land on the rocks. On the following day, he purchased another parcel of land that was farther up the hill. There he built his first house, which is thought to be the first house ever built in Portland. The house was located southwest of Commerce Street, toward the river. The house was eventually torn down, and the land it occupied was used for quarrying purposes. This sketch depicts the Stancliff house and its surroundings.

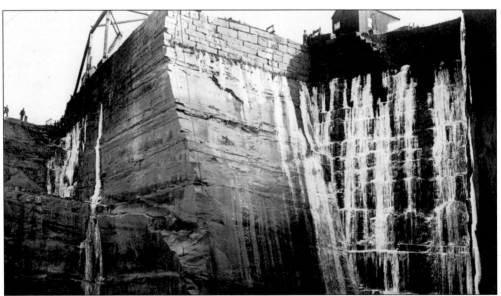

This image shows the Portland Brownstone Quarry with machinery on the rim and icy veils of groundwater frozen on the walls.

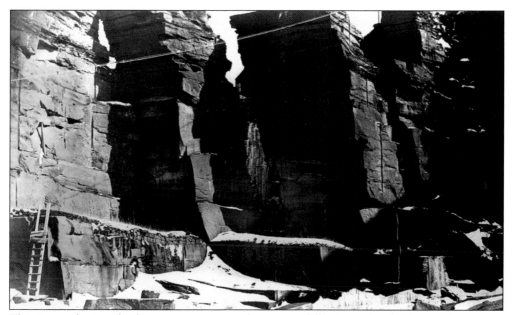

This image depicts the brownstone quarry after a snowfall. A wooden ladder can be seen at the left.

This is a northwest view of the brownstone quarry riverfront, looking across the Connecticut River toward Cromwell. Numerous arches—ox-drawn devices for lifting and moving blocks of stone in a chain sling—can be seen here.

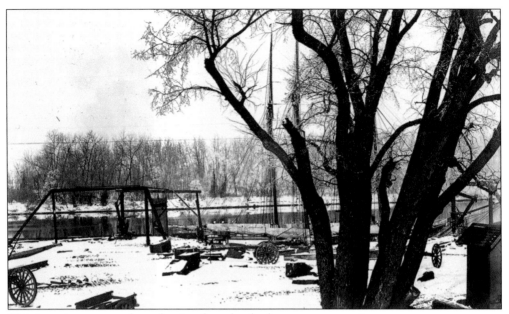

This is a winter scene along the riverfront by the brownstone quarries.

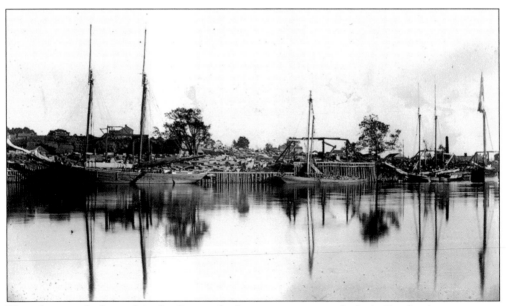

This photograph shows ships loading at the brownstone quarry docks in Portland.

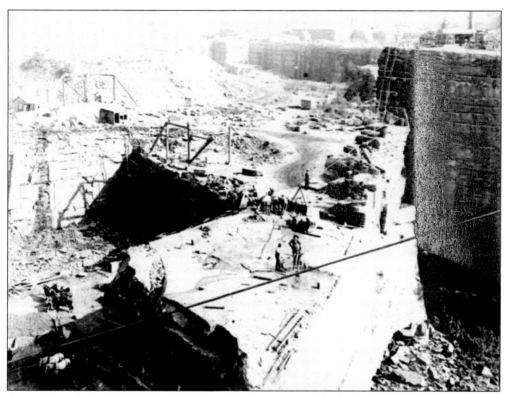

At the upper level are a steam boiler and compressor that are being used by the workmen below. This view looks toward Silver Street.

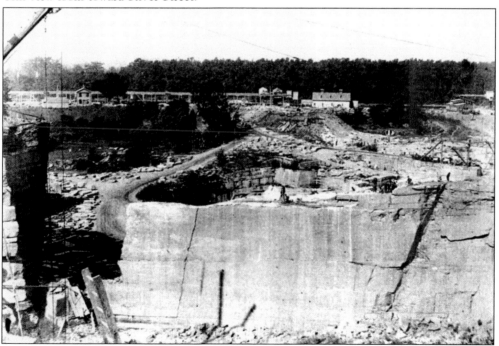

This is a westward view of the brownstone quarry, looking toward the Connecticut River.

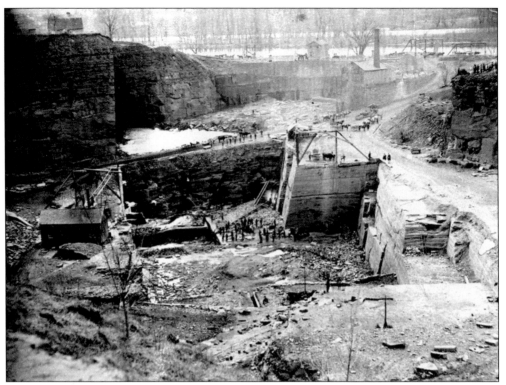

This photograph shows a westward view of the Brainerd Quarry. Willow Island in the Connecticut River can be seen in the background. Silver Street runs down the hill on the left of this photograph.

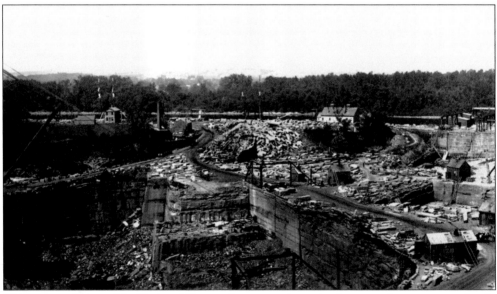

This westward view of the Brainerd Quarry shows a road running between the current peninsula on the right to the current promontory on the left.

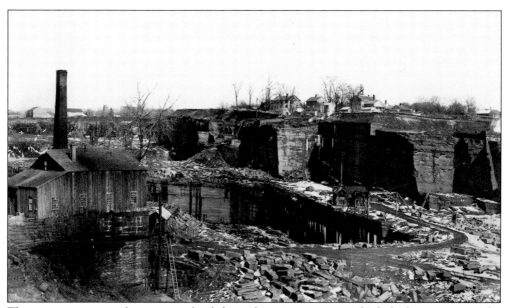

The promontory can be seen to the left in this winter scene, which looks east across the Brainerd Quarry.

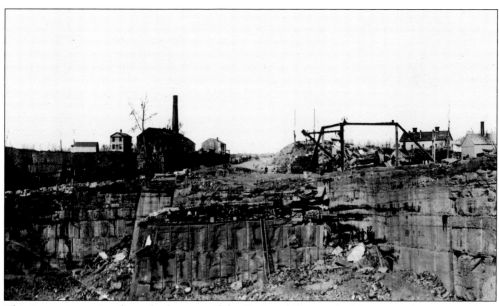

This is a unique view from the bottom of the Brainerd Quarry, looking up at the western rim.

113

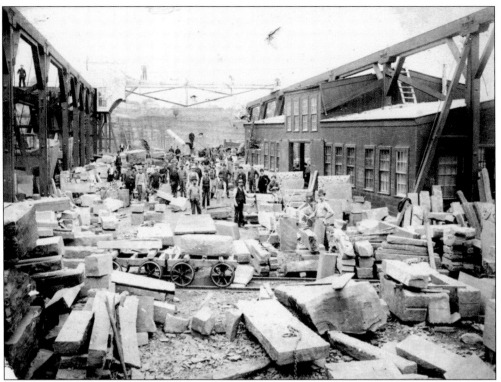

Workers pause to be photographed in the quarry stockyard.

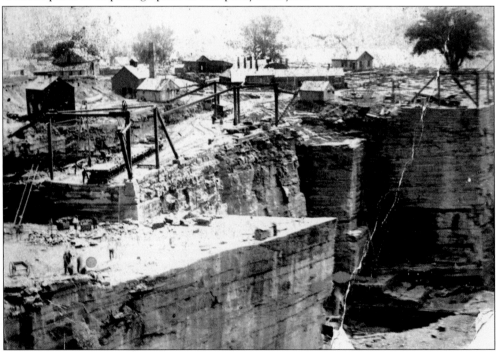

This photograph, taken by Eben Hall in 1889, shows a view of the quarry somewhere along the eastern rim.

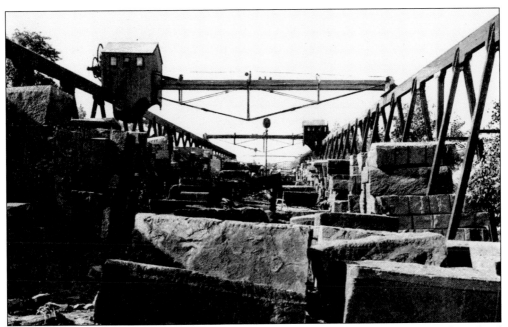

In the 1890s, the traveling derricks above the brownstone quarries were in operation from April to November, after which there was a cold-weather layoff.

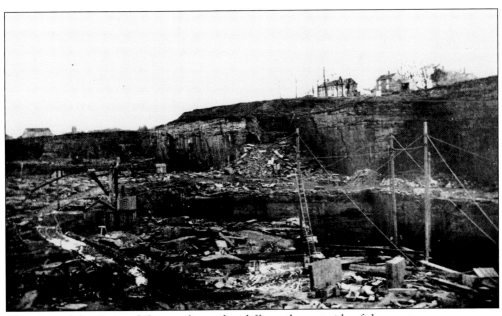

This view of the Brainerd Quarry shows the cliffs on the east side of the quarry.

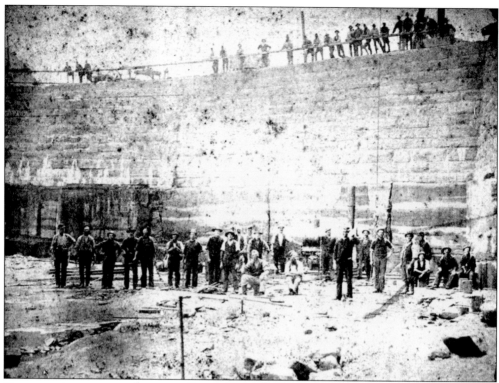

Quarry workers pose on the quarry floor and at the railing along the top of the wall.

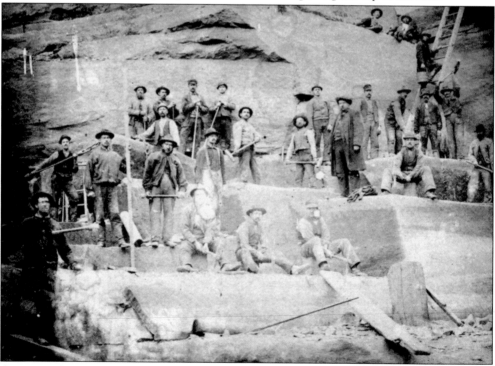

Quarry workers pose with their tools in the quarry hole.

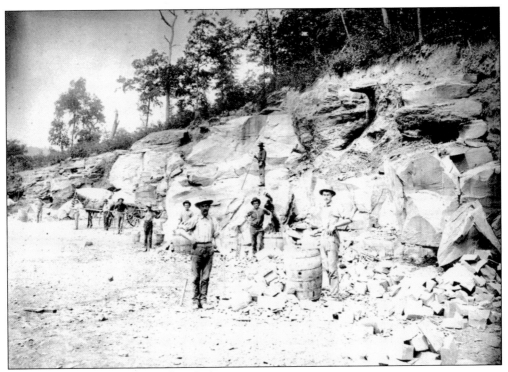

Quarry workers pose in an unidentified quarry.

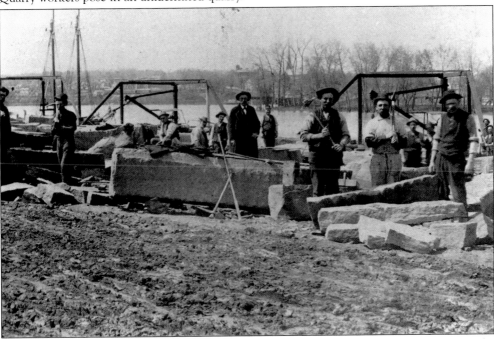

This photograph was taken c. 1890 at the Shaler and Hall Quarry. The gentleman in the long coat in the center of the photograph is Daniel Webber Graham, the yard foreman. "Webb" Graham was born in 1842 and was the grandson of Capt. Issac Webber, who owned the Savage Shipyard in Cromwell. He died in 1915 and is buried in Trinity Cemetery.

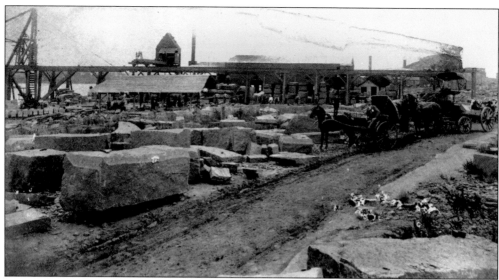

E. I. Bell was the proprietor of the Connecticut Steam Brown Stone Works Company in Portland.

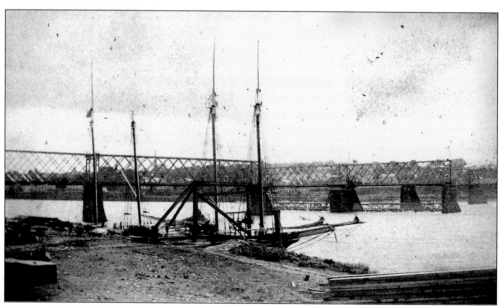

A schooner waits at the dock on the Connecticut River in Portland for a load of brownstone. Notice the Air Line Railroad Bridge crossing the river.

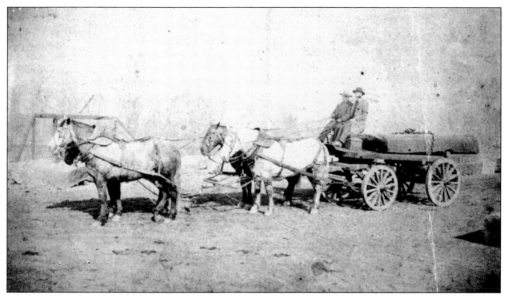

Seen in this 1889 photograph is the four-horse team of Shaler and Hall Quarry Company with driver Eben Hall.

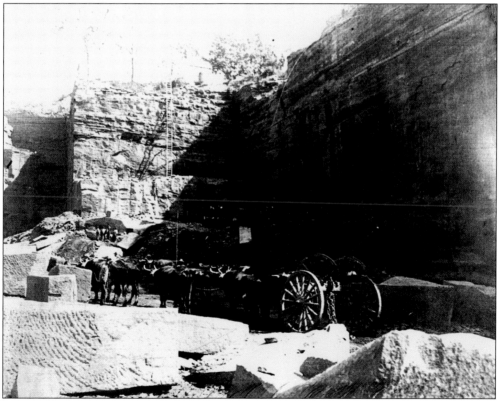

Oxen rest on the bottom of the brownstone quarry with an idle arch; the lift lever is released and the chain sling is empty.

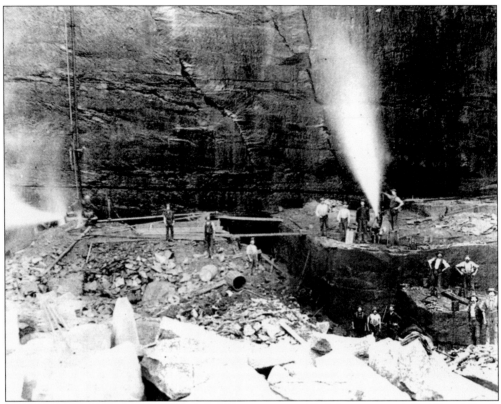

Workmen pose at the lower level while blowing steam off of their power drills. The difficult working conditions are apparent in this photograph, taken in the late 19th century.

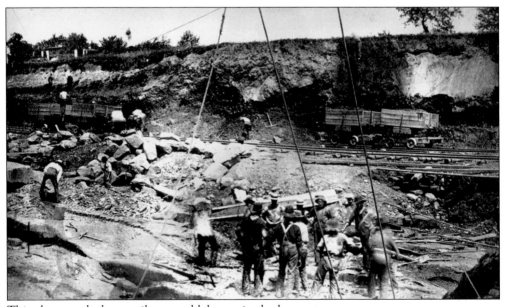

This photograph shows rail cars and laborers in the brownstone quarry.

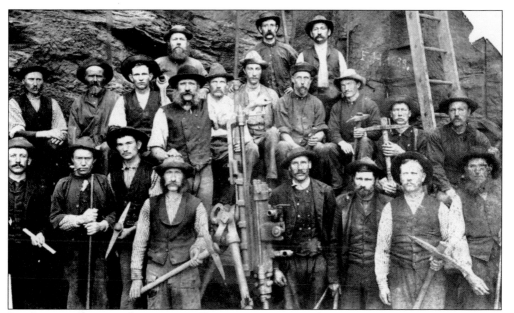

Brownstone quarry workers in F. Hurlbut's gang appear in this June 3, 1889, photograph.

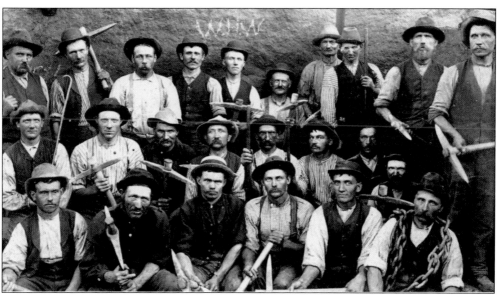

Posing for a group photograph, many with the tools of the trade on their shoulders, are the men of H. S. Watrous's gang. They are seen here on June 4, 1889. The bowler hats worn with the typical costume of the period, while giving some protection from small stones and dirt, gave scant relief from the heavier stones that caused death and injury to many of the early workers.

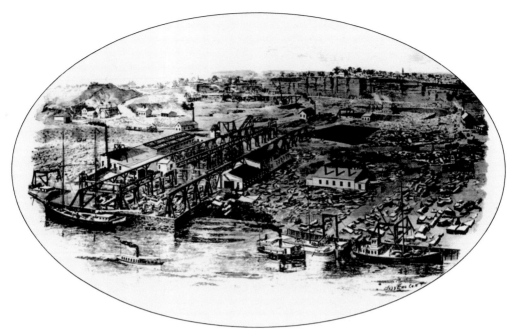

The bird's-eye lithographs of the 19th century were popular with commercial establishments as a means of showing their holdings. This one of Mill No. 2 appeared in the catalog of the Connecticut Steam Brownstone Company. After consulting maps and land records, the artist would visit the site to draw the separate buildings, then would find a high vantage point and finish the perspective. While fairly accurate, the drawings were usually idealized and compacted.

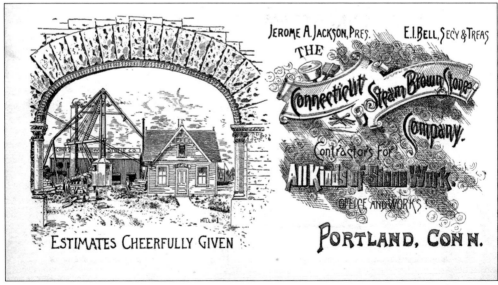

This promotion card was used by the Connecticut Steam Brown Stone Company. The reverse of this card touts "Mill No. 2. unsurpassed facilities for shipping stone by water or rail. We take the entire contract for the erection of stone buildings complete, or for furnishing the stone in any quantity."

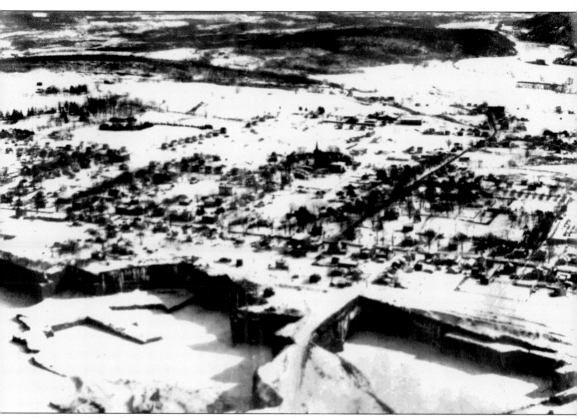

Portions of the three quarries can been seen in this photograph. To the left (north) was the was the Middlesex Quarry Company, at the center was the Brainerd Quarry Company, and to the right (south) was the Shaler and Hall Quarry Company. Silver Street runs along the high ground between the two southern quarries. Snow covering downtown Portland can be seen at the top (east). The photograph was taken by *Hartford Courant* staff photographer Edward A. Berendt. The article was entitled "Portland as seen from the Air and Ground" and appeared in the March 29, 1936, edition of the *Hartford Courant*.

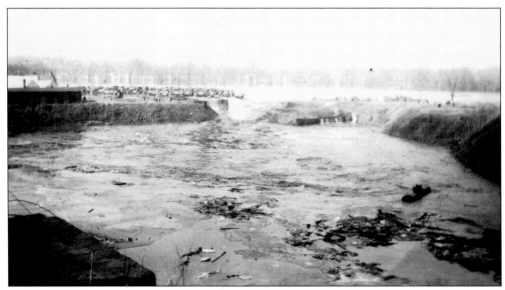

At 8:00 a.m. on March 19, 1936, the Connecticut River breached it banks and began to flood the lower quarry. This sequence of four photographs shows the Connecticut River as it flooded the lower quarry on that Thursday morning.

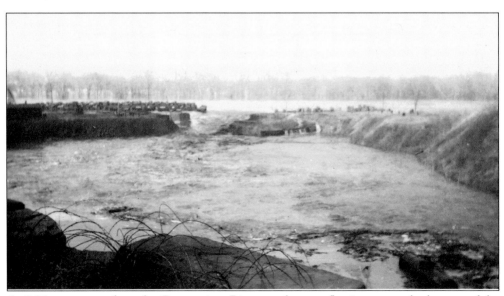

At 8:04 a.m., water from the Connecticut River can be seen flowing across the bottom of the lower quarry

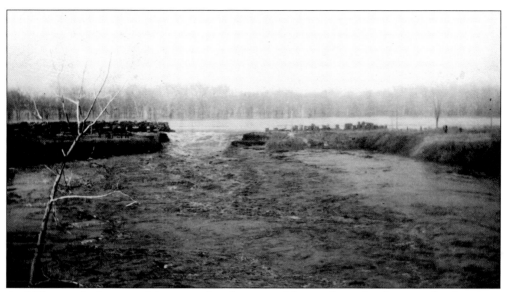

At 8:08 a.m., the bottom of the quarry has disappeared from sight under the rising flood waters.

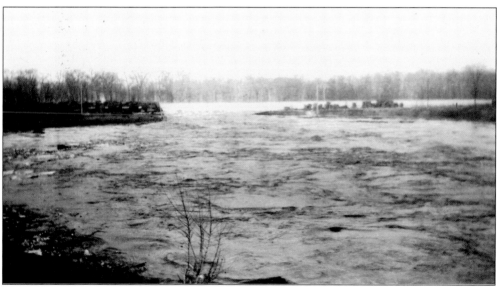

By 8:15 a.m., the water level in the quarry was even with the Connecticut River, less than 15 minutes after the river overflowed its banks. This flood was the final blow to the quarry operation, which was already facing dwindling profits; brownstone was no longer in fashion, and concrete and steel construction had already eroded their market share.

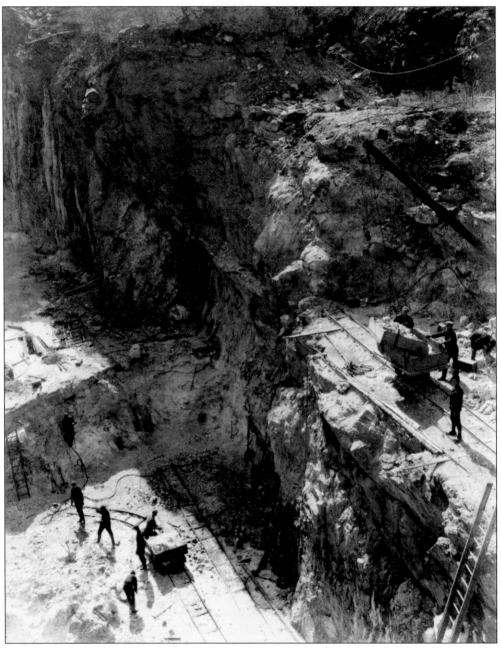

There were several other quarry operations in Portland. This 1921 photograph shows the feldspar quarry located in the vicinity of Isinglass Hill. It was known as the Hale Quarry. The quarry output was trucked to Feldspar Corporation in Middletown for milling.

REFERENCES

Centennial Celebration of Portland, Connecticut. Centennial Celebration Committee, 1941.

Hill, Ted, Jim Hallas, and Michael Osiecki. *150th Anniversary Book.* 150th Anniversary Committee, 1991.

Loether, J. Paul, Gail Linskey Porteus, and Doris Darling Sherrow. *The History and Architecture of Portland.* Greater Middletown Preservation Trust, 1980.

Perkins, Julia, Bernadette S. Prue, and Claudette Kosinski, eds. *Long Ago, Not Far Away: An Illustrated History of Six Middlesex County Towns.* Greater Middletown Preservation Trust, 1996.

Seventy-Fifth Anniversary of Portland, Connecticut. Portland Board of Trade, 1916.

The History of Portland, Connecticut, 1976. Portland Historical Society, 1976.

Van Beynum, William J. *Portland Connecticut: 125 Years of Incorporation.* Selectmen's 125th Anniversary Committee, 1966.

INDEX